Be Alright!

Be Alright!

Don White

Copyright © 2017 by Don White.

Library of Congress Control Number: 2017905840
ISBN: Hardcover 978-1-5434-1631-2
 Softcover 978-1-5434-1630-5
 eBook 978-1-5434-1629-9

All rights reserved. No part of this book may be reproduced or transmitted in any form or by any means, electronic or mechanical, including photocopying, recording, or by any information storage and retrieval system, without permission in writing from the copyright owner.

Any people depicted in stock imagery provided by Thinkstock are models, and such images are being used for illustrative purposes only.
Certain stock imagery © Thinkstock.

Print information available on the last page.

Rev. date: 04/26/2017

To order additional copies of this book, contact:
Xlibris
1-888-795-4274
www.Xlibris.com
Orders@Xlibris.com
760700

About the Author

First of all I would like to thank you for taking the time to view my drawings and I'm sure you'll notice that they are hand drawn. I'm a retired carpenter who is more comfortable with a hammer and nail in my hands rather than a pen and paper. The hands and eyes aren't what they once were.

This all started when I made my own sudoku puzzles and I would doodle in them to add a little color. One day my daughter noticed what I was doing and for Christmas that year she gave me adult coloring books, which I didn't know existed but thought that it was a great idea! After completing the books I received, I went on to create my own. After a few ink cartridges and a couple stacks of paper my wife said, "Too bad you couldn't do something with all your drawings.". So now, a couple of years later, here we are.

I hope you enjoy coloring these as much as I did making them. Feel free to add to the drawings as some of them are designed just for this reason. You might be surprised by what you can do and when you're finished you might say "Be Alright!"

Dedicated to my wife for inspiring me to do this, Love you Sheryl.

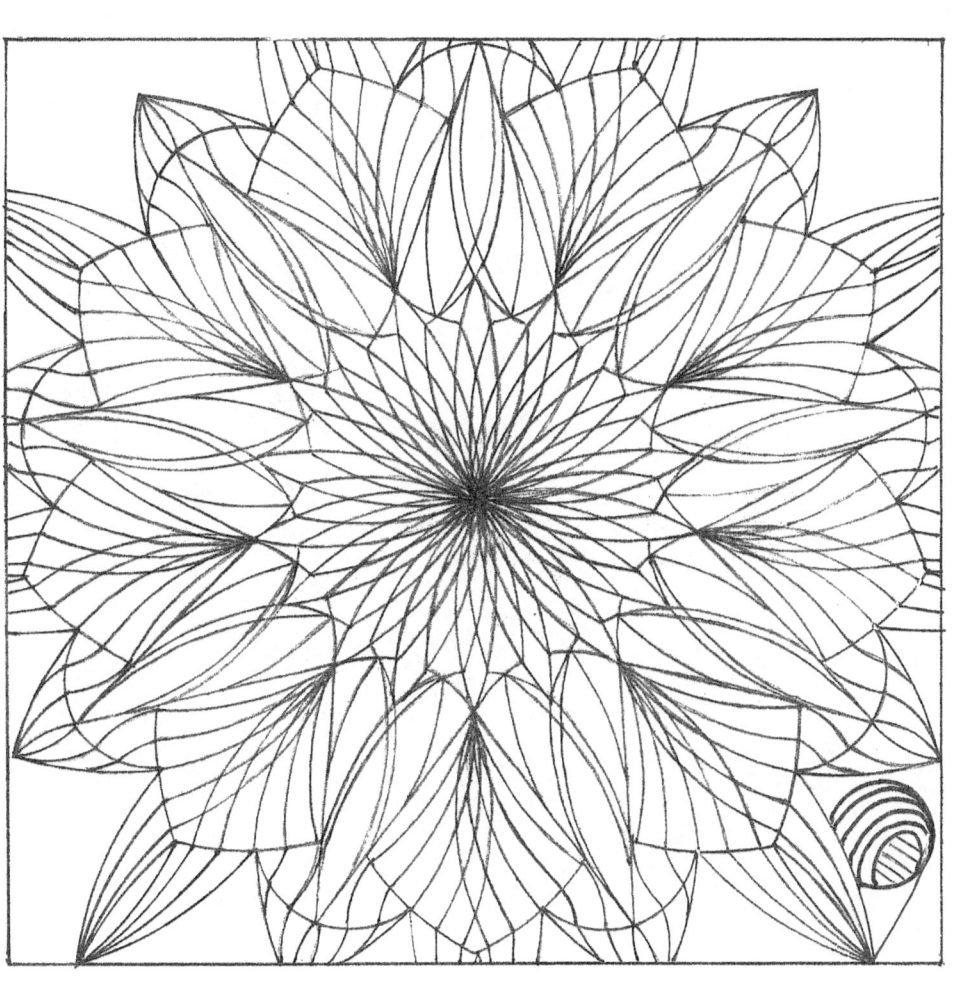

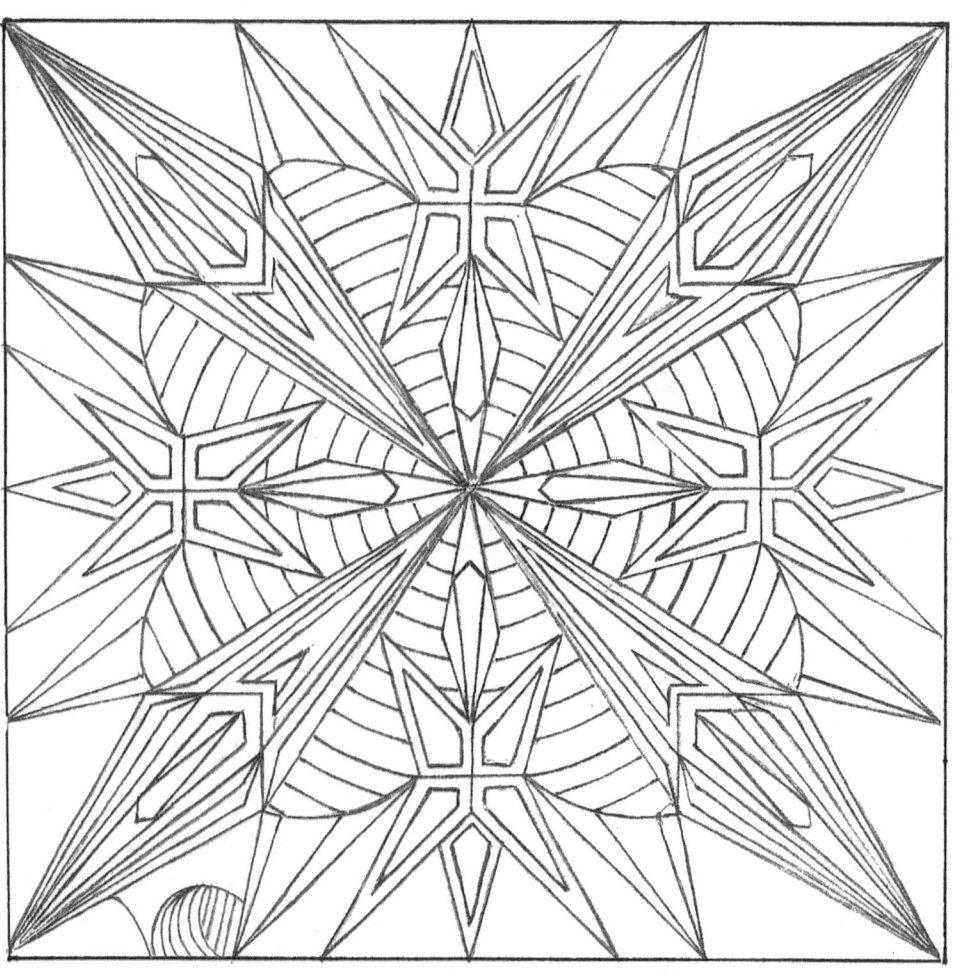

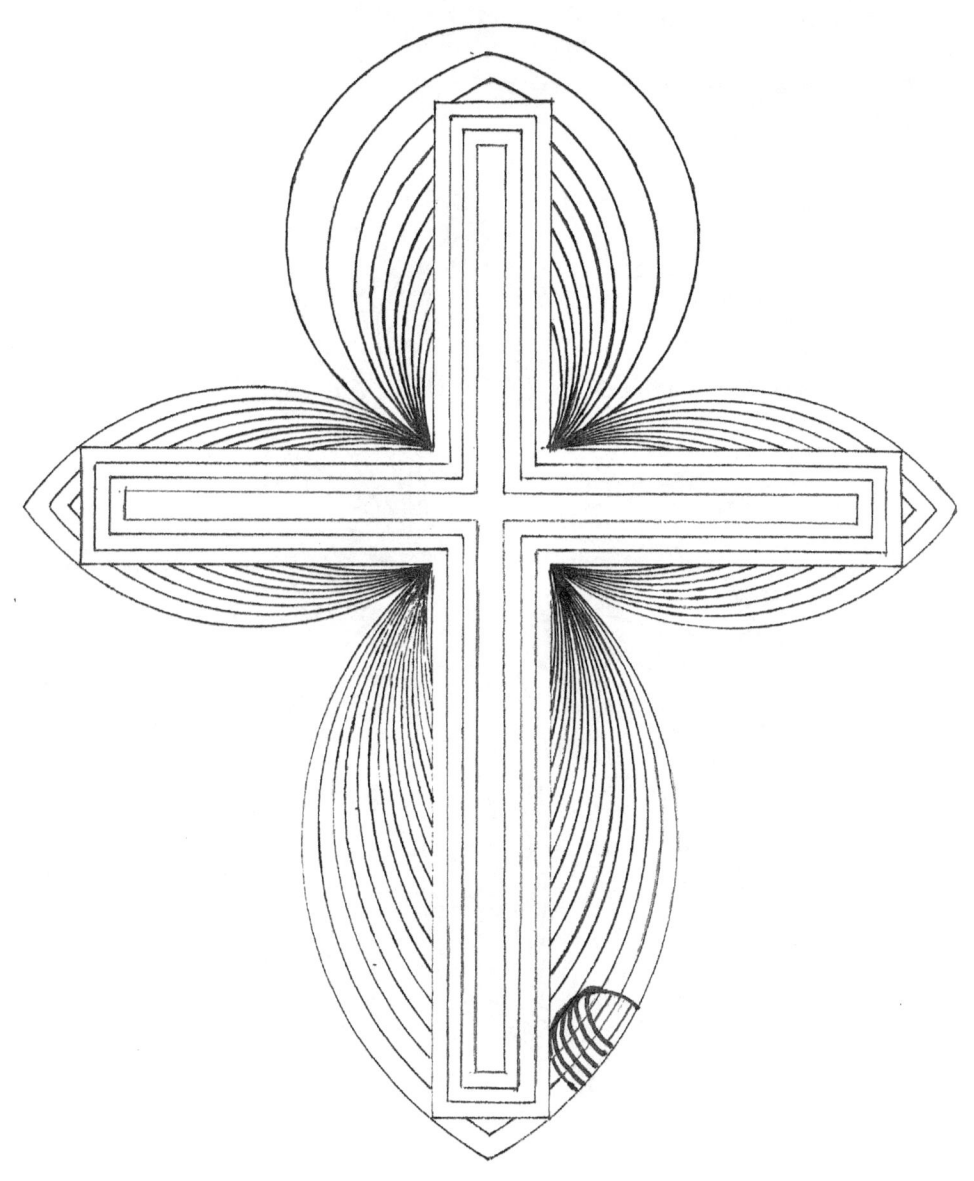

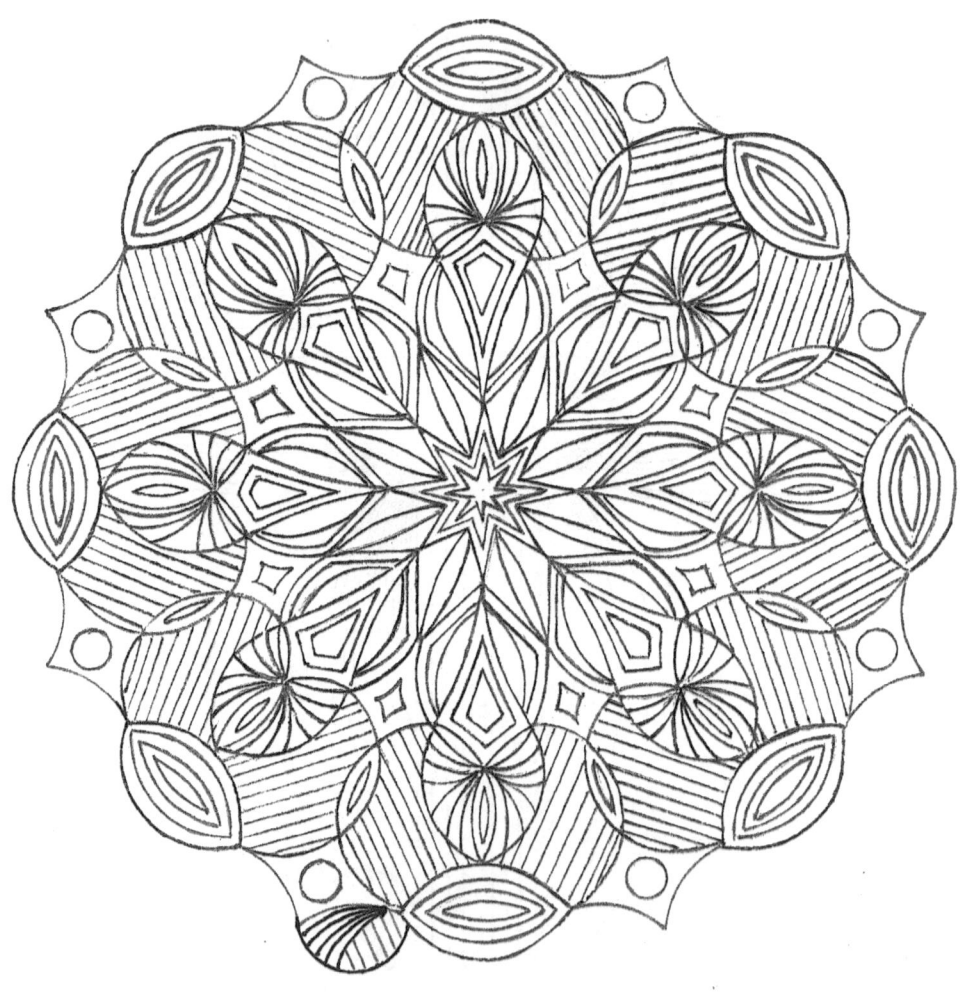

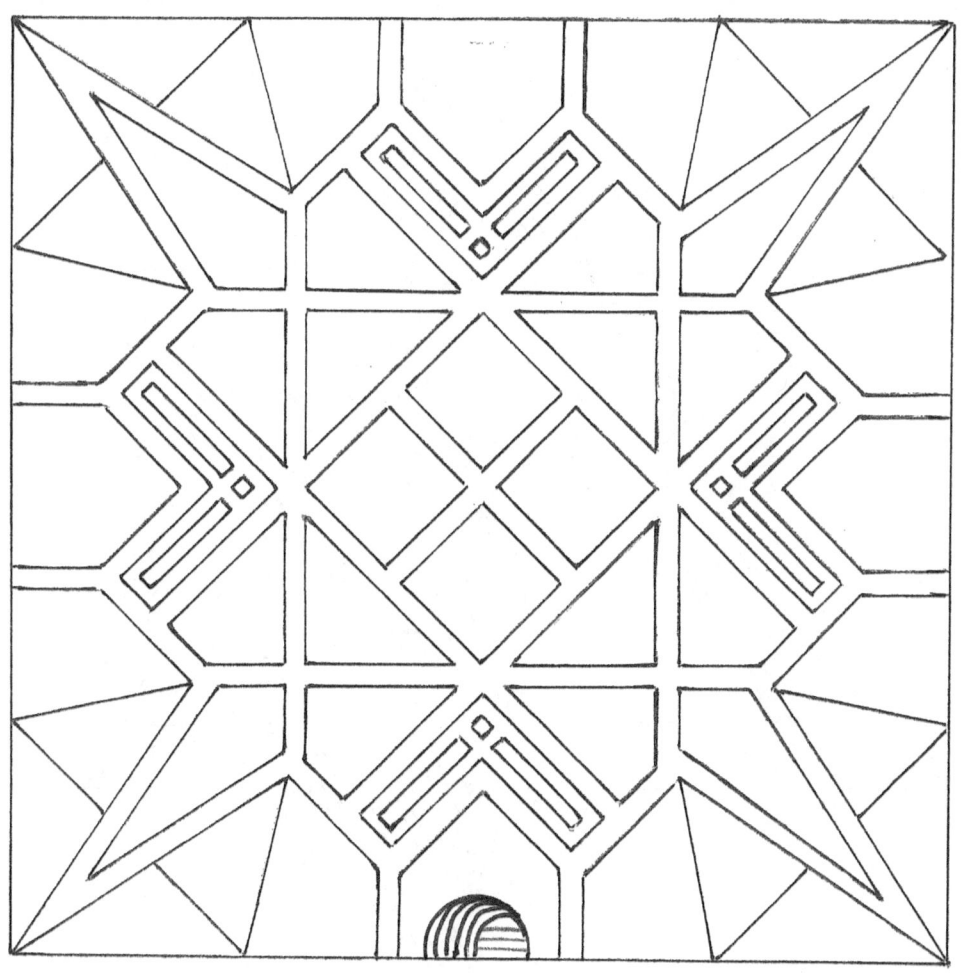

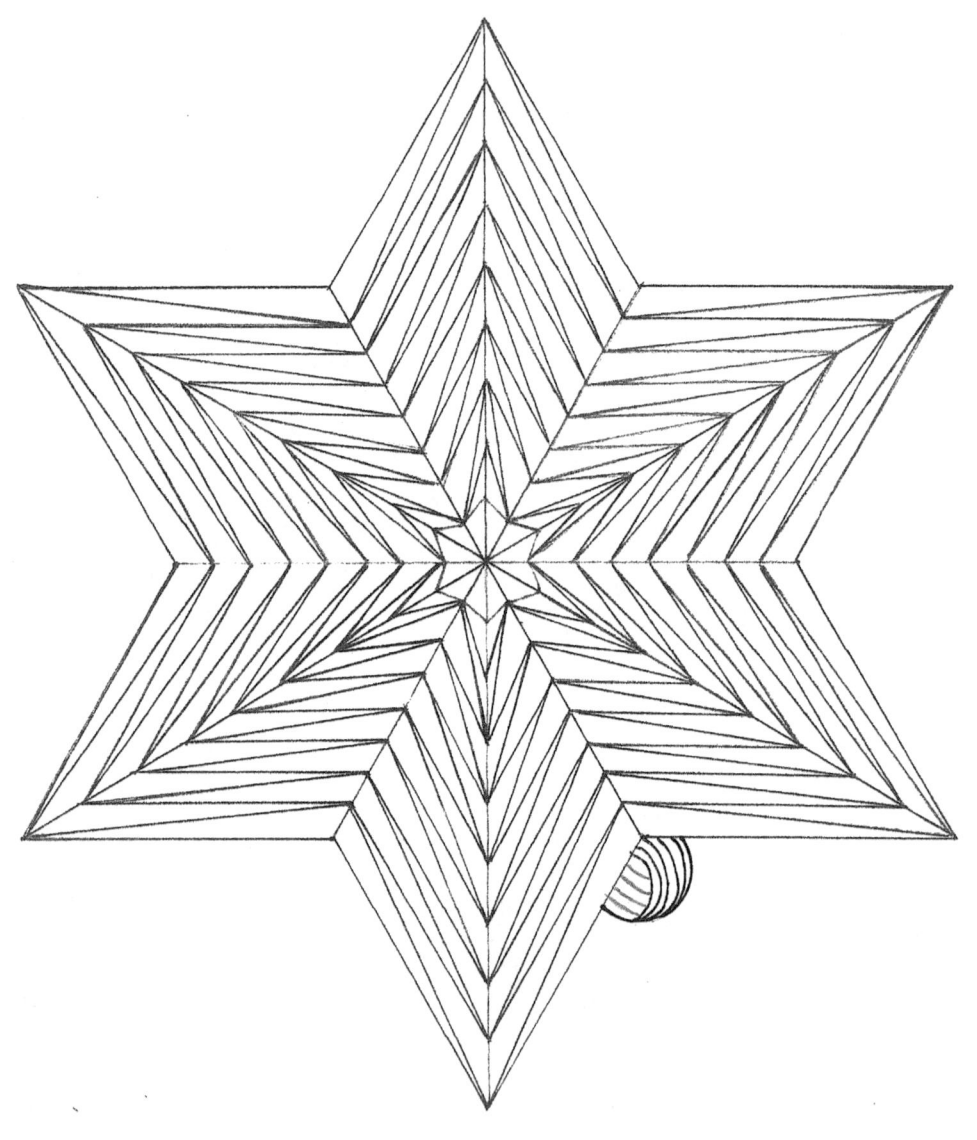

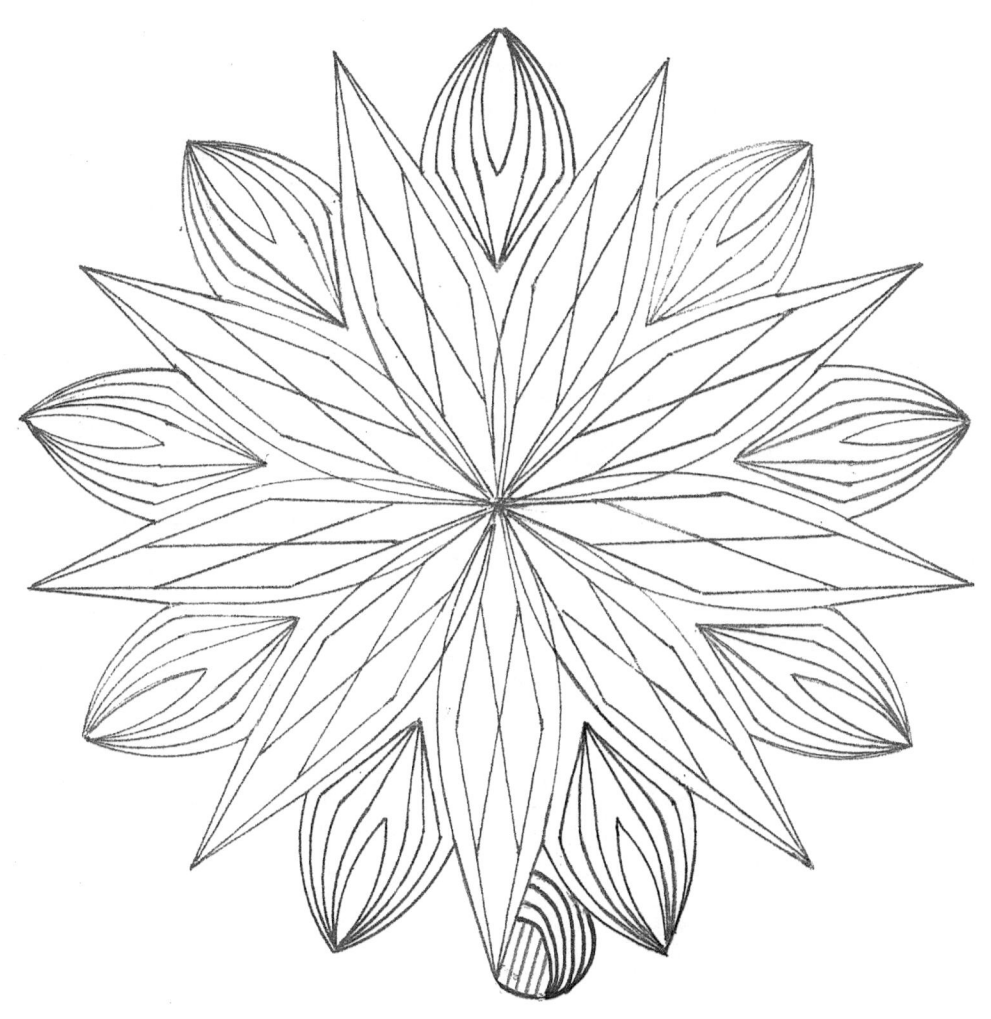

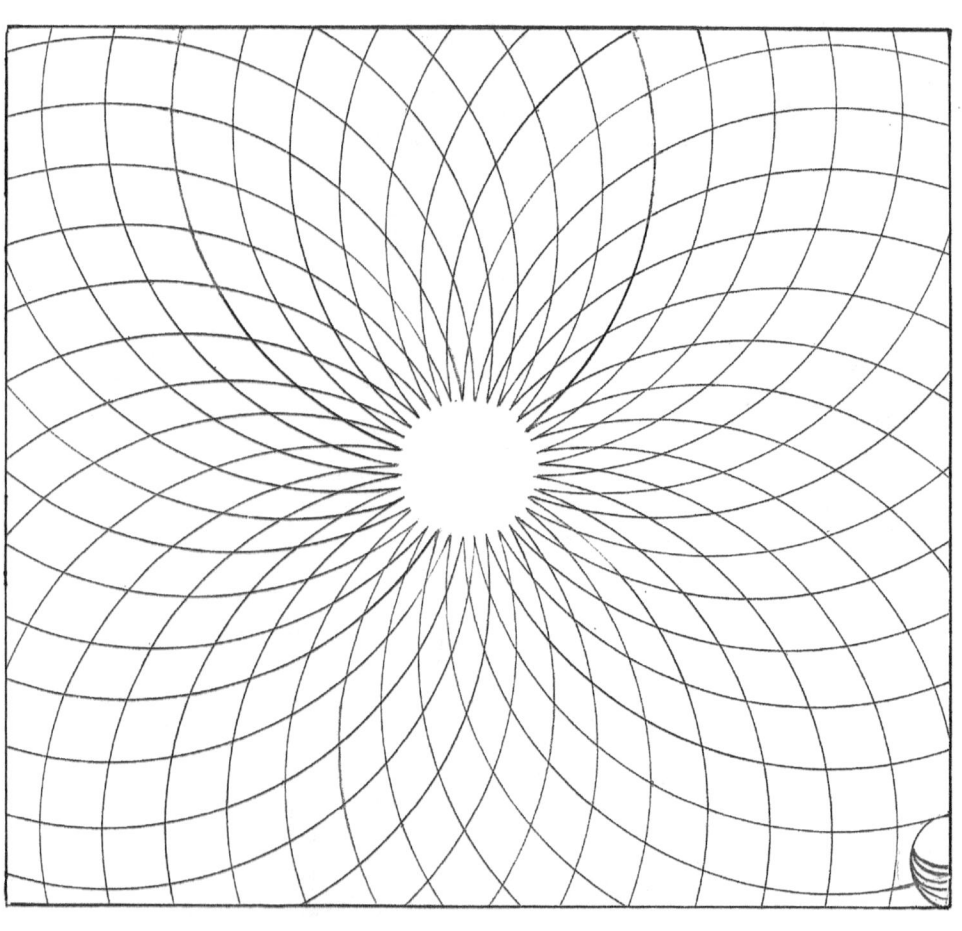

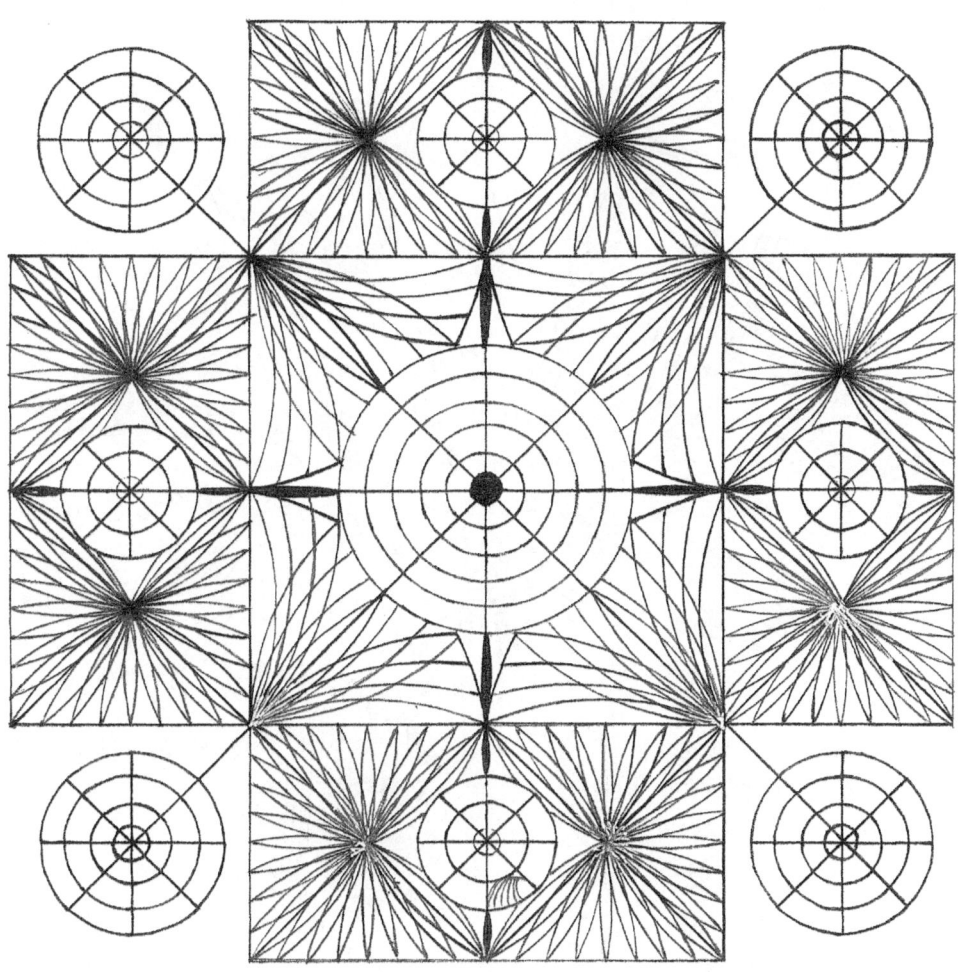

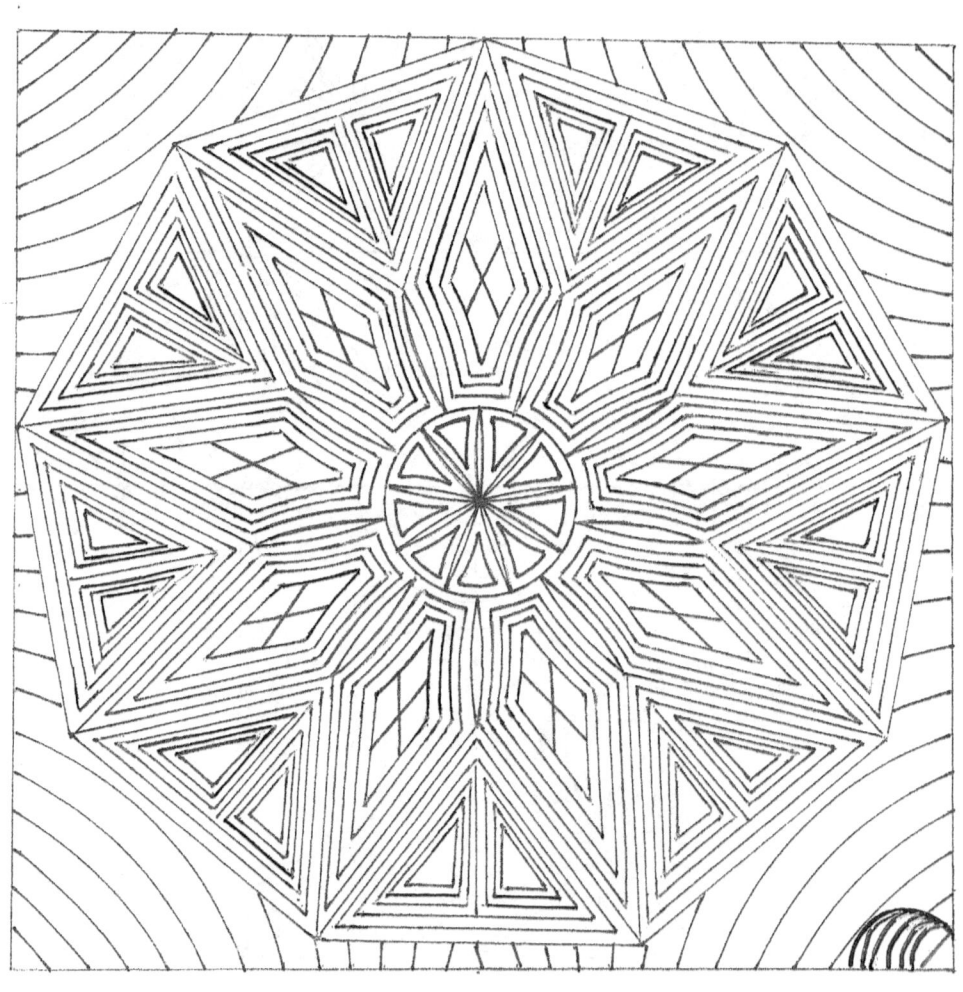

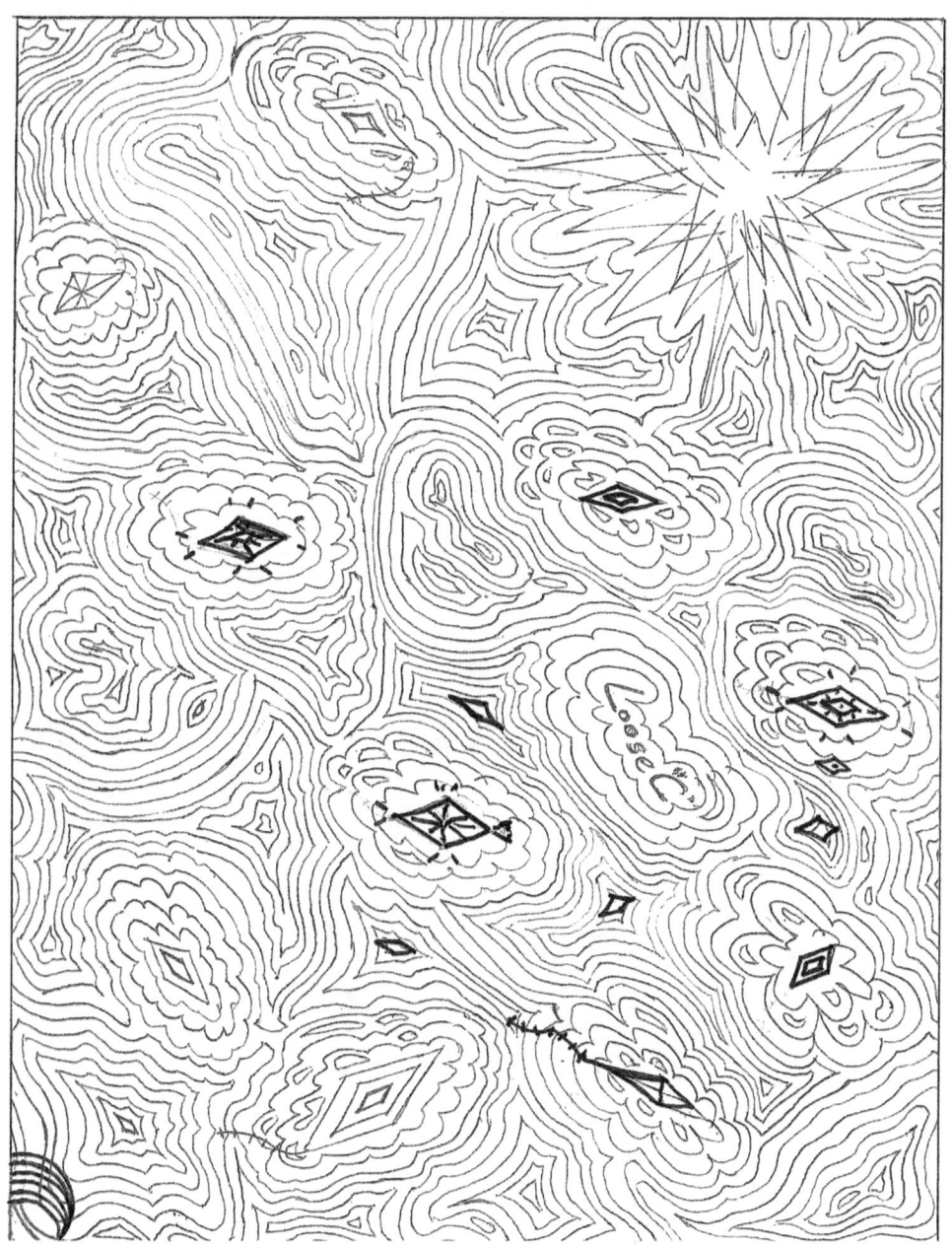

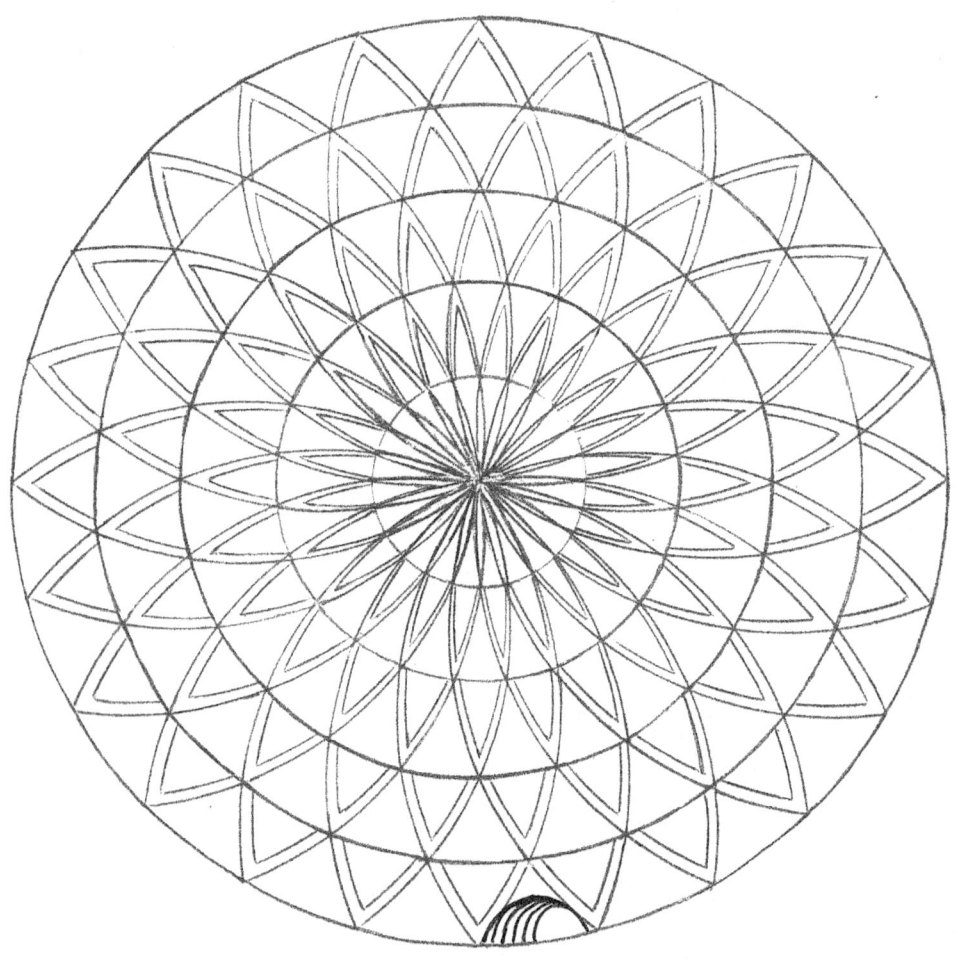

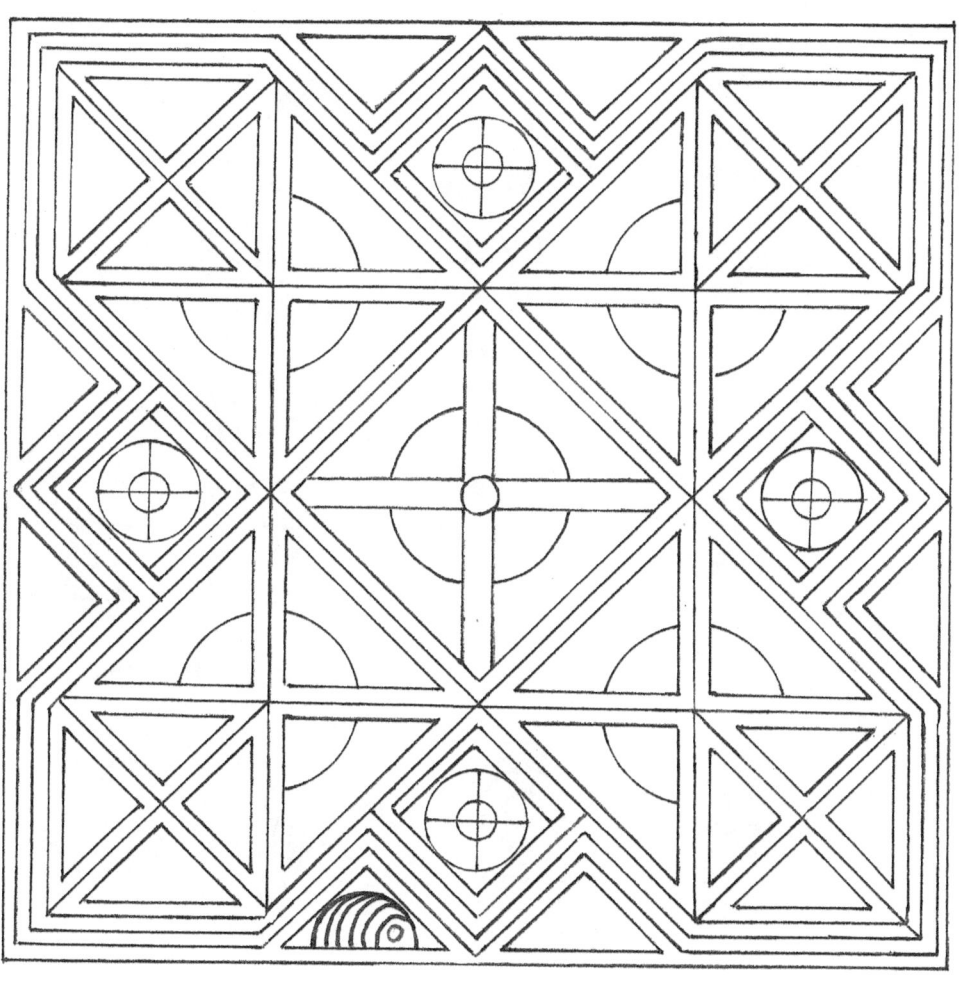

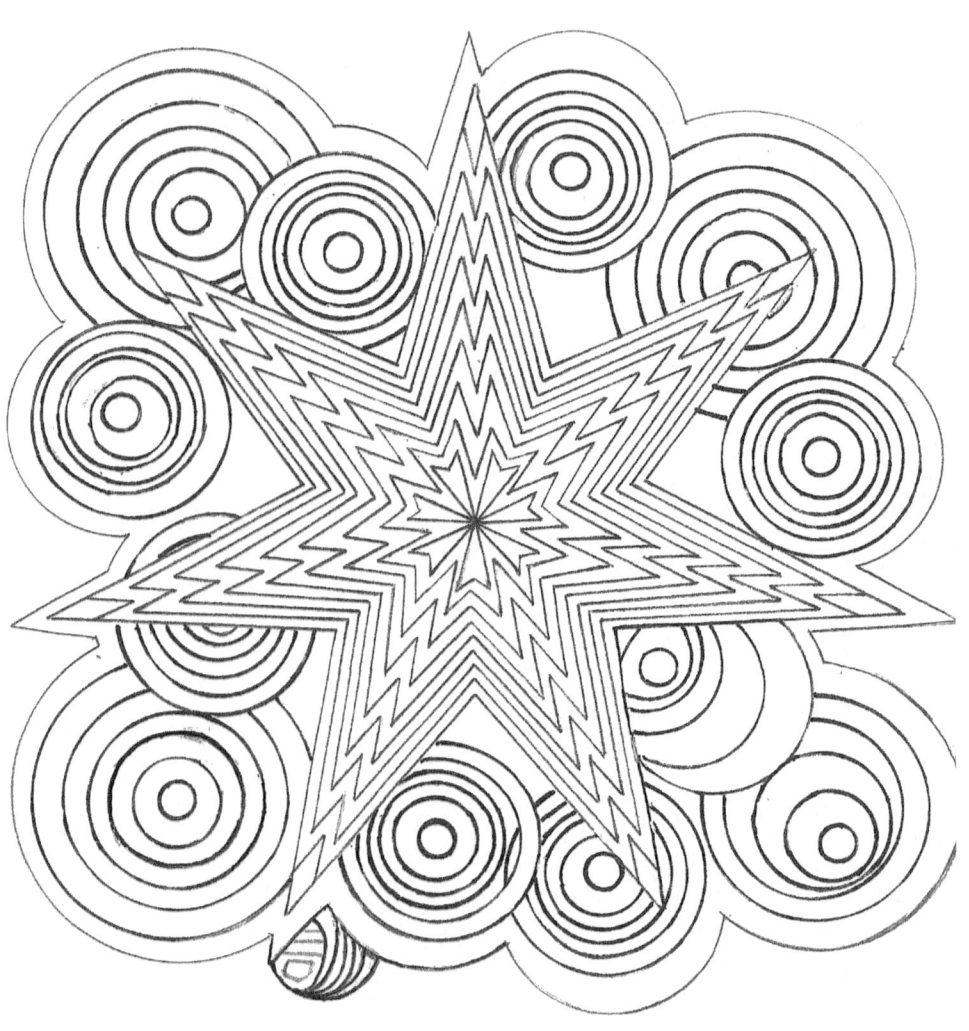

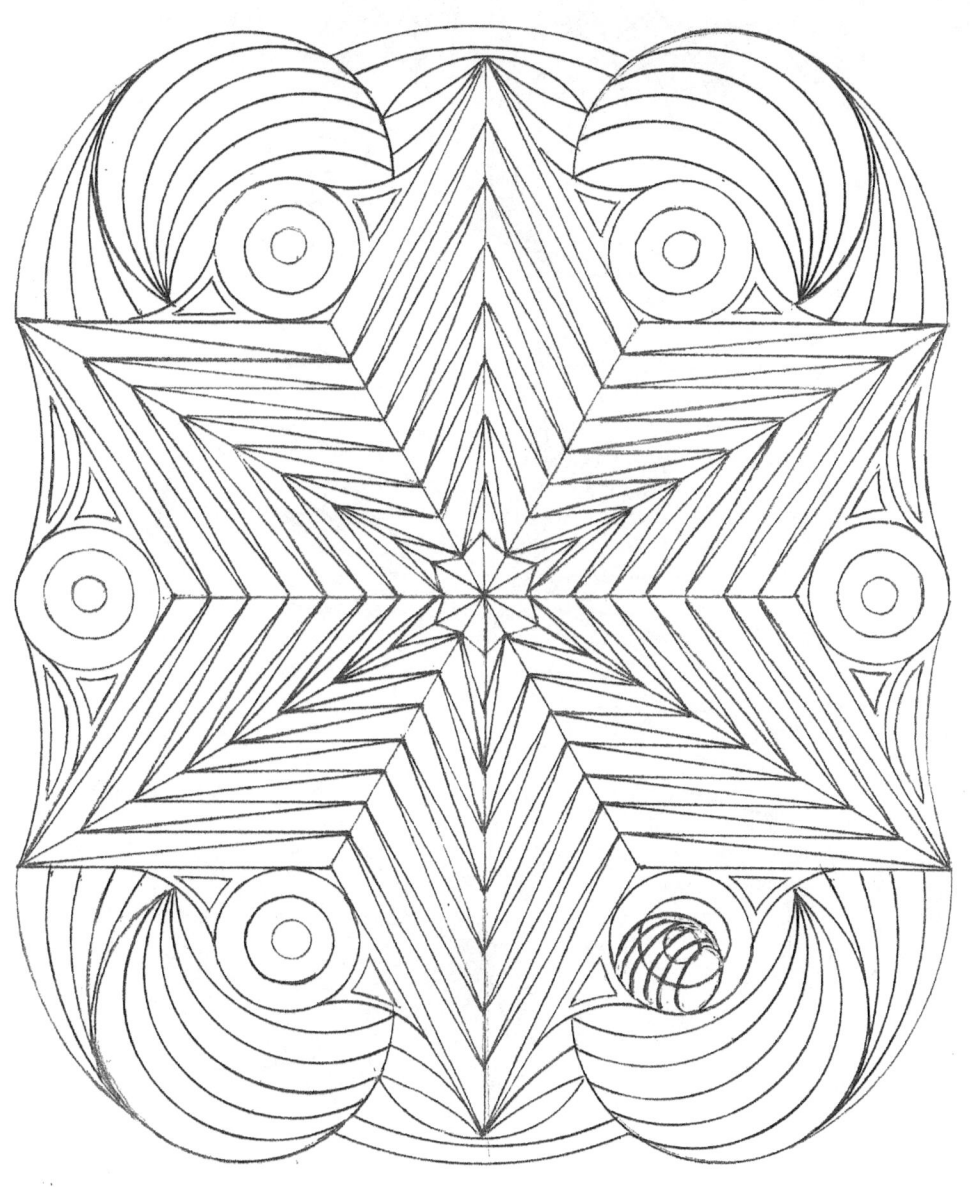

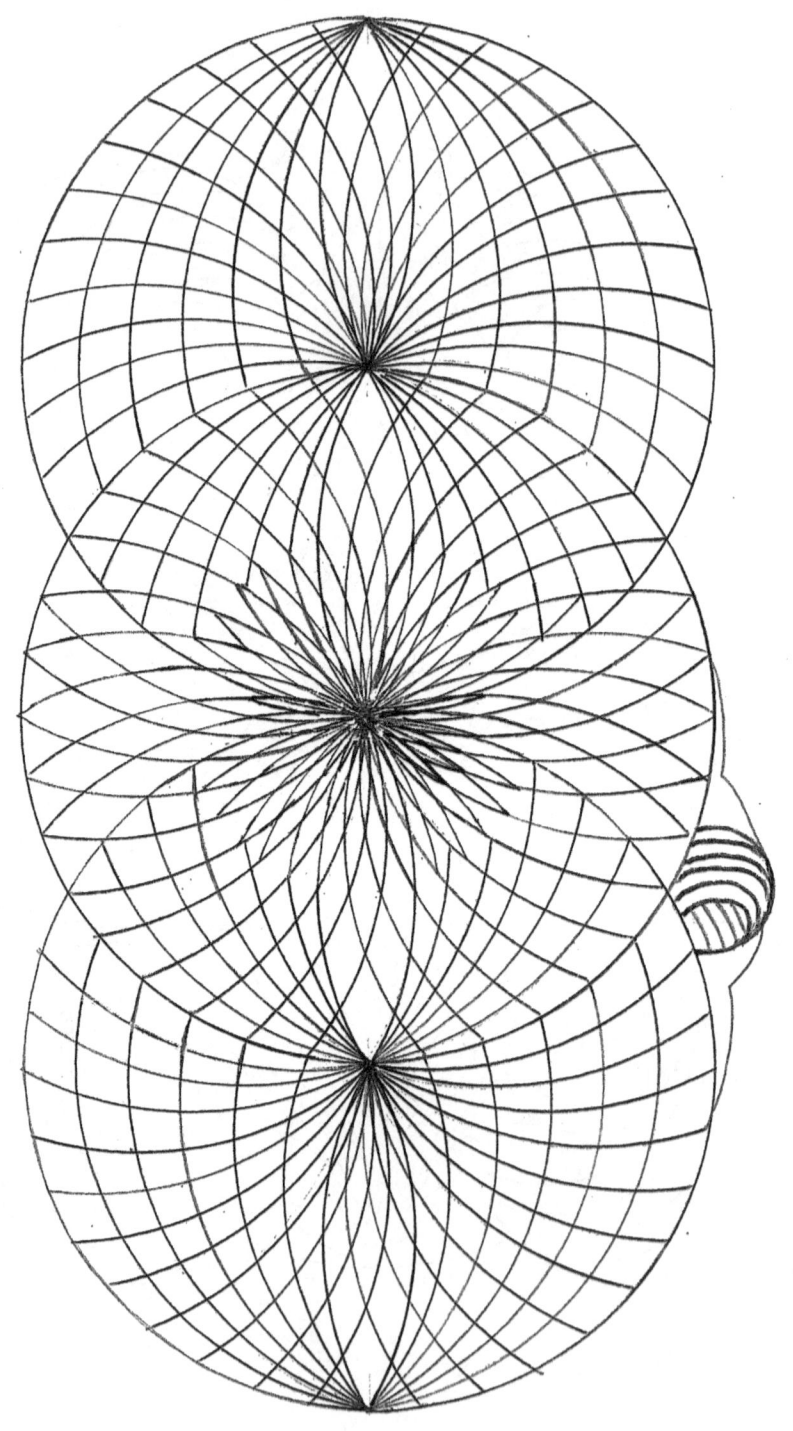

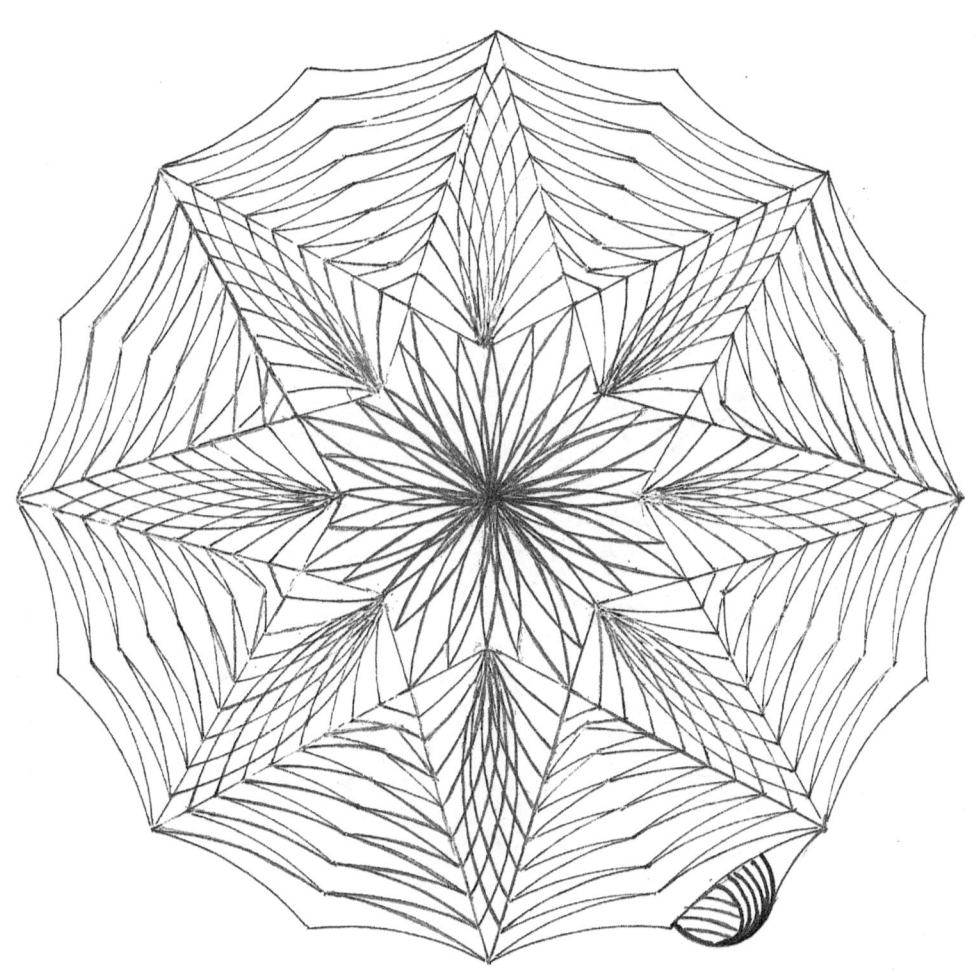

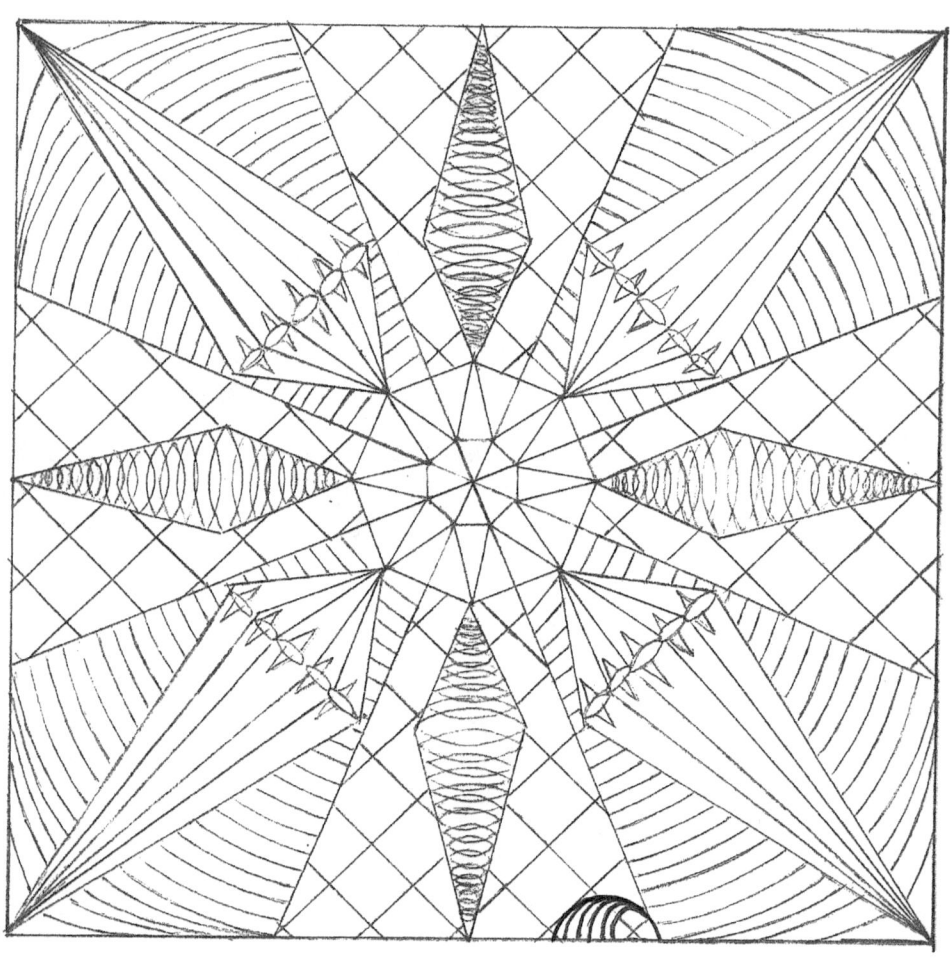

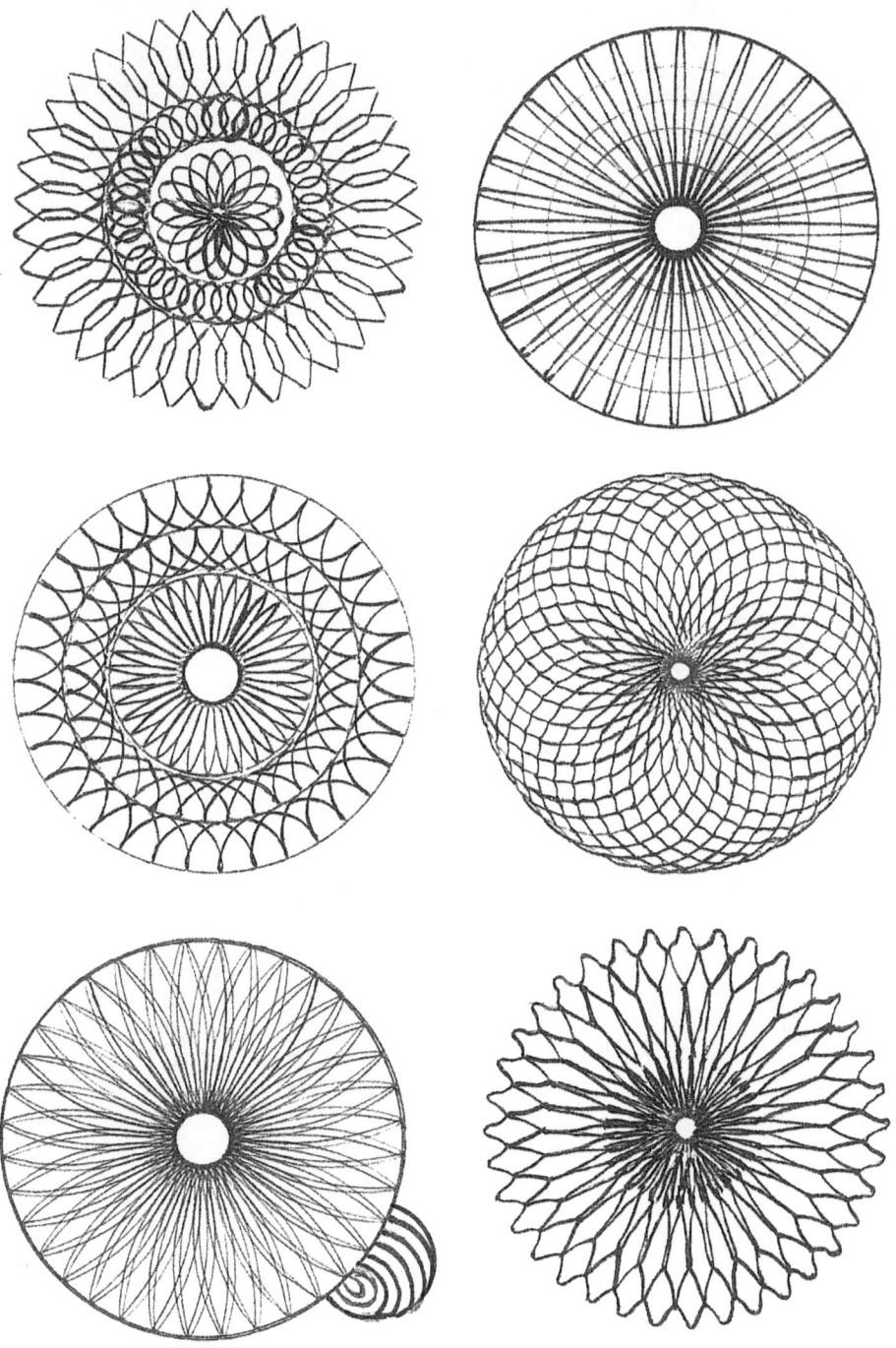

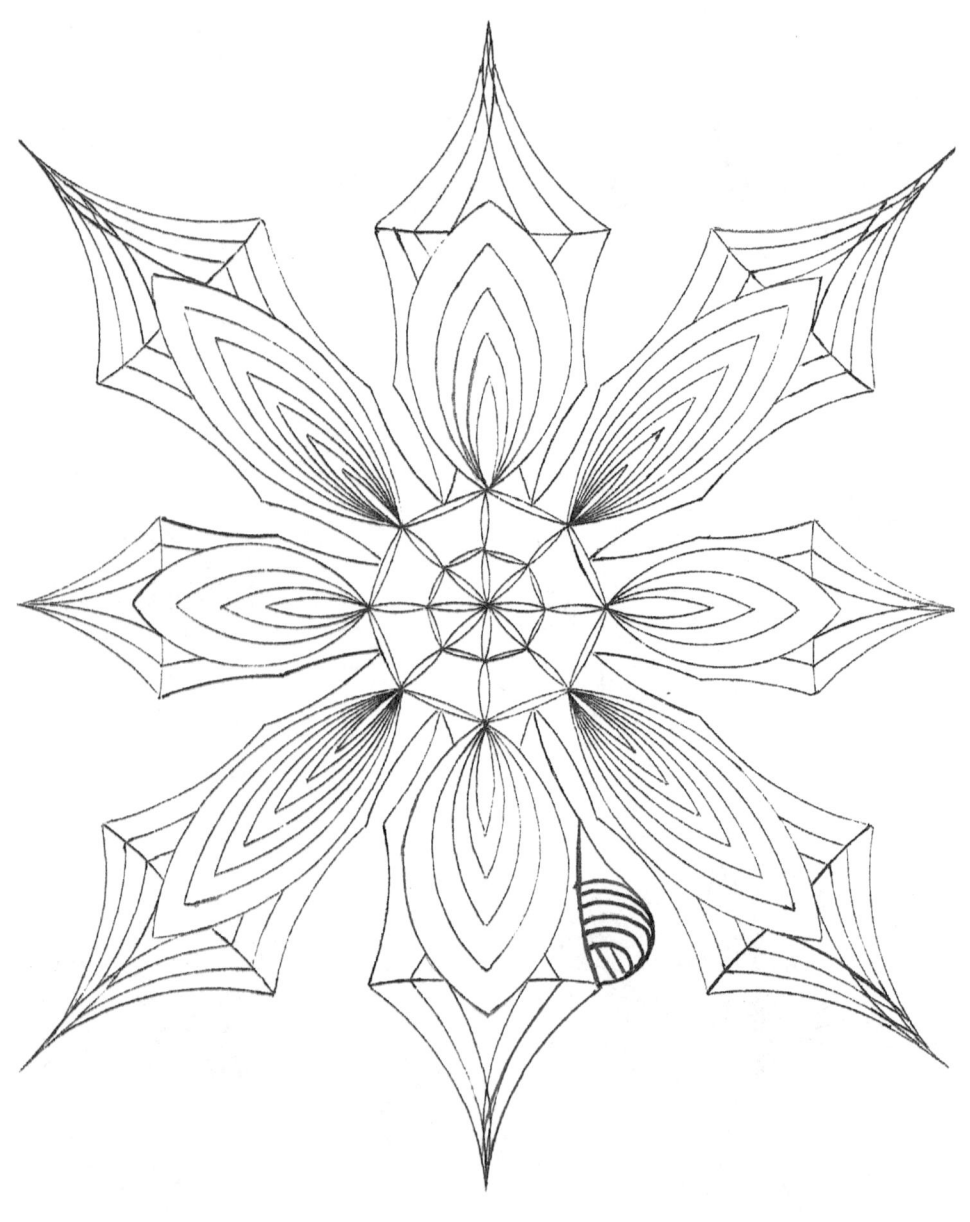

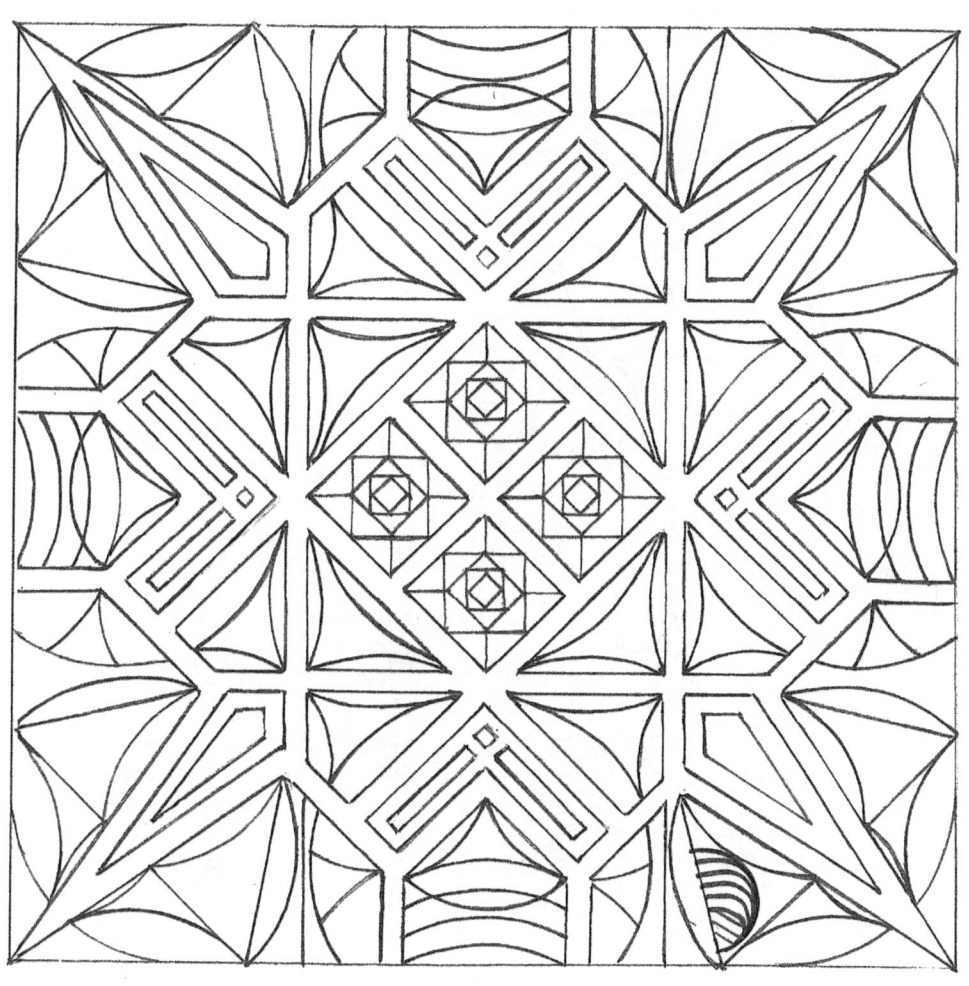

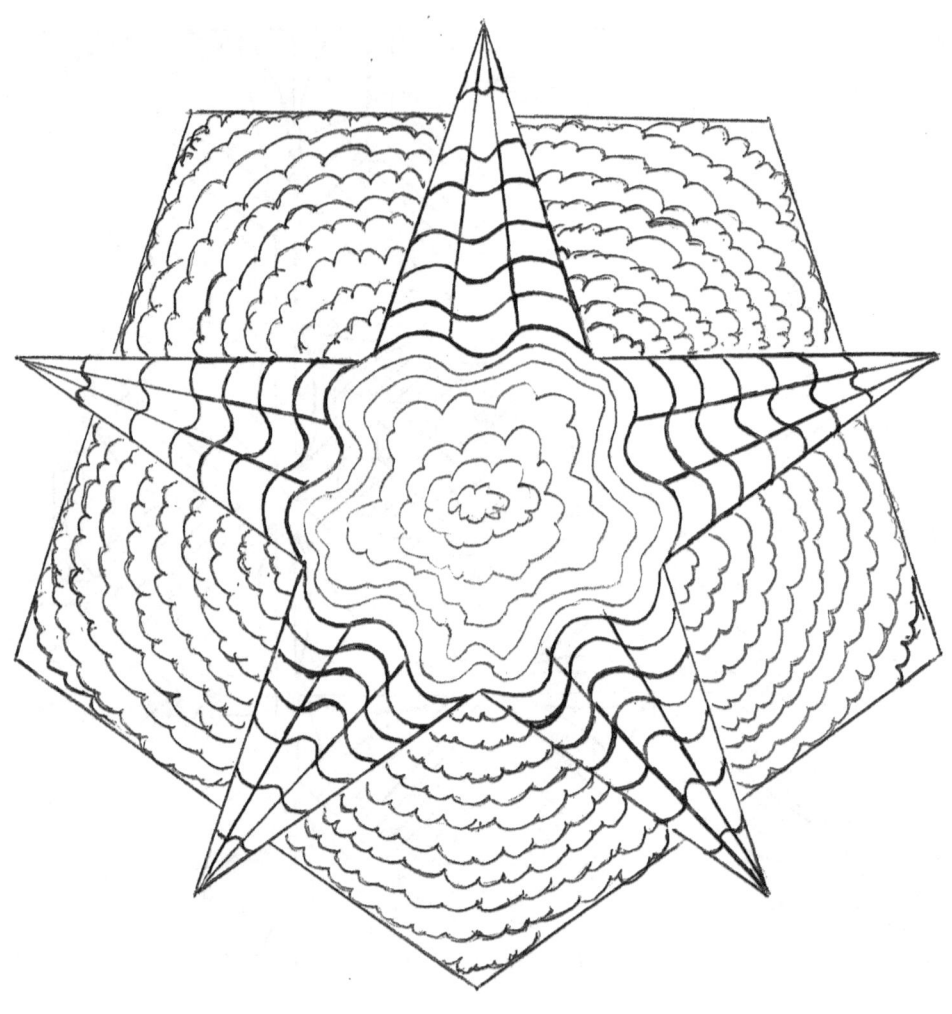

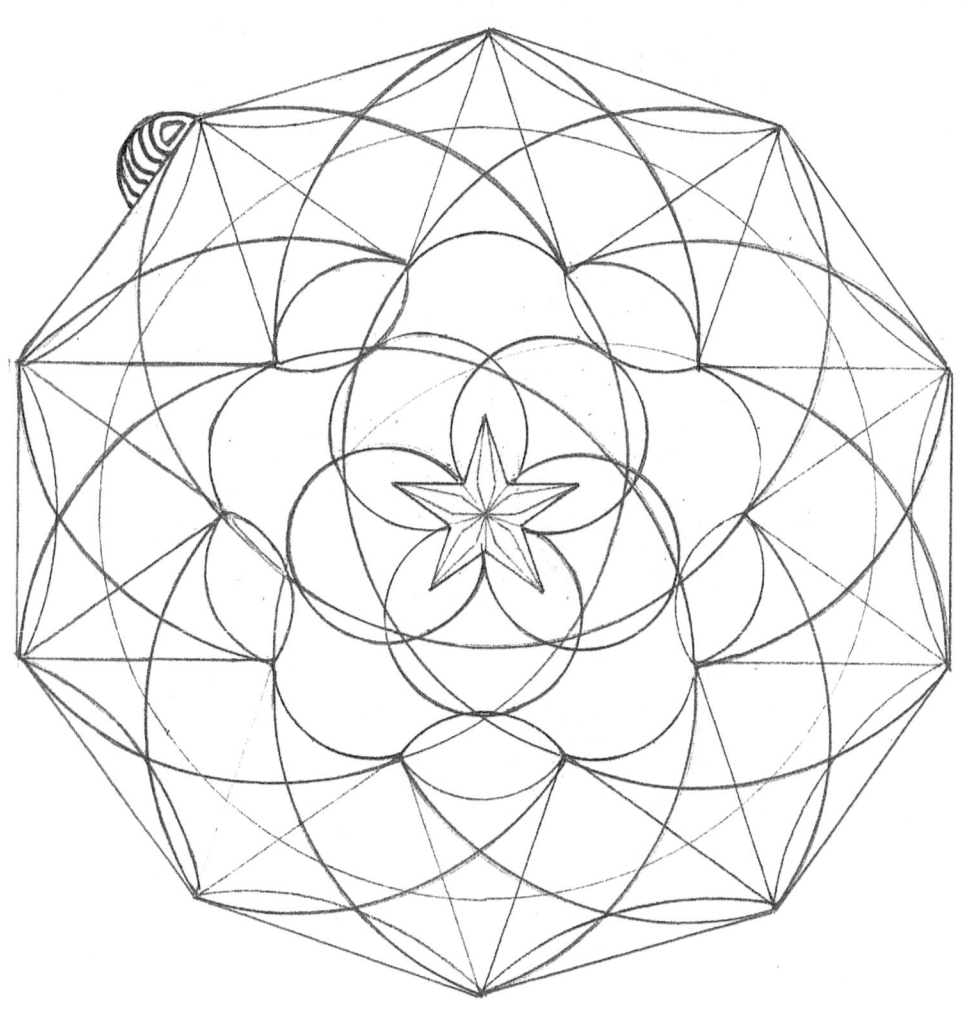

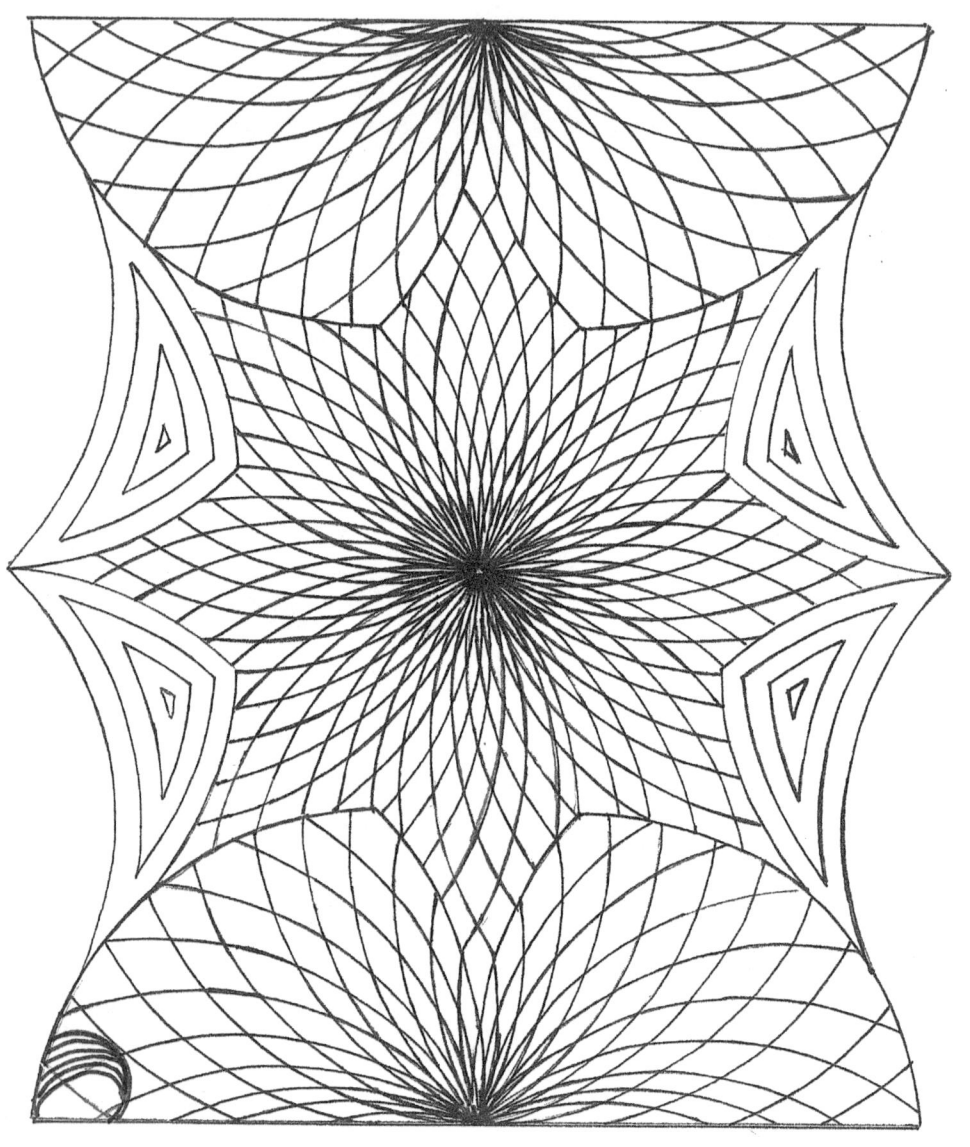

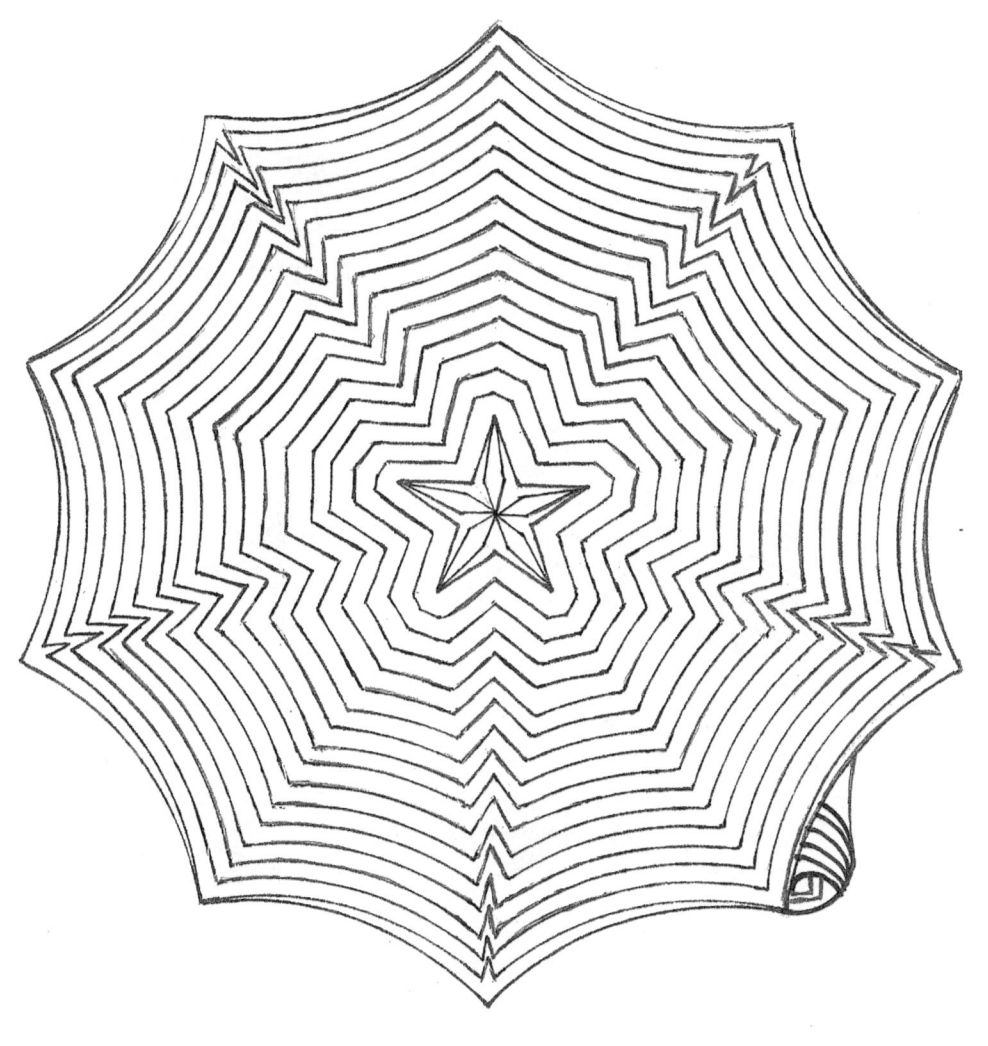

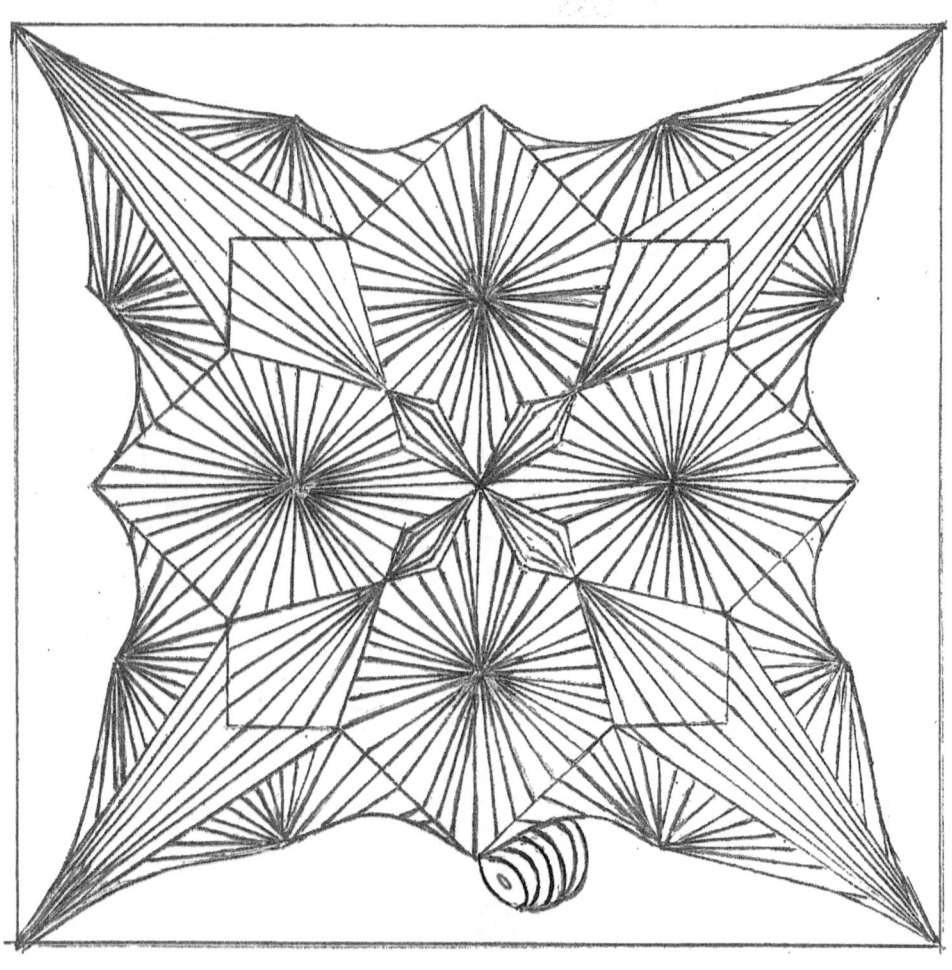

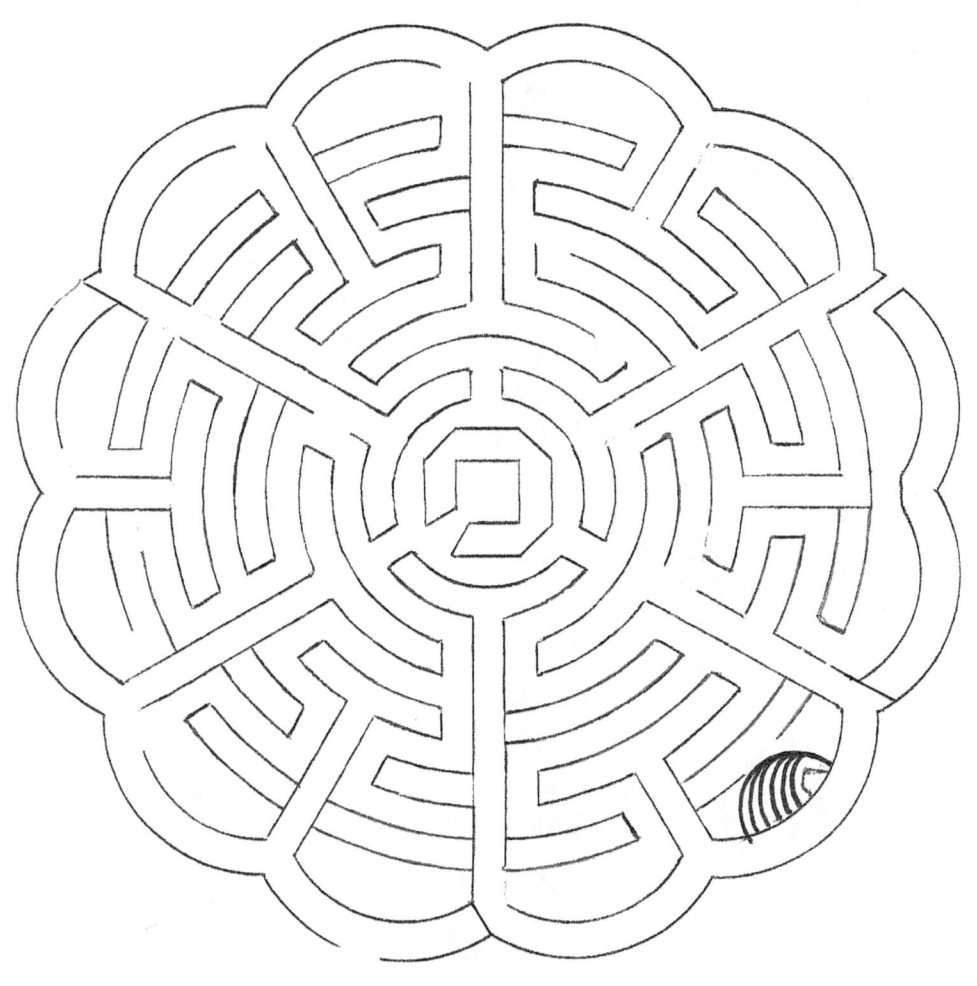

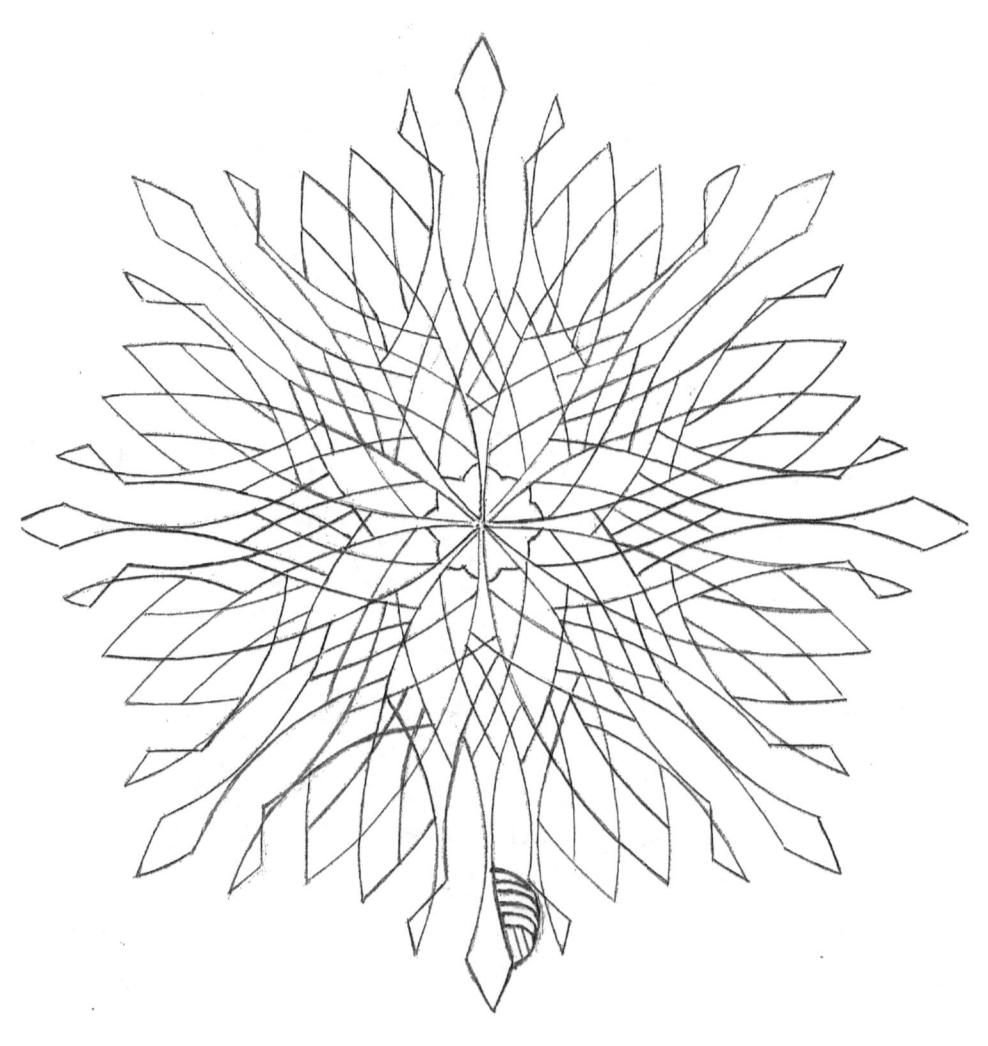

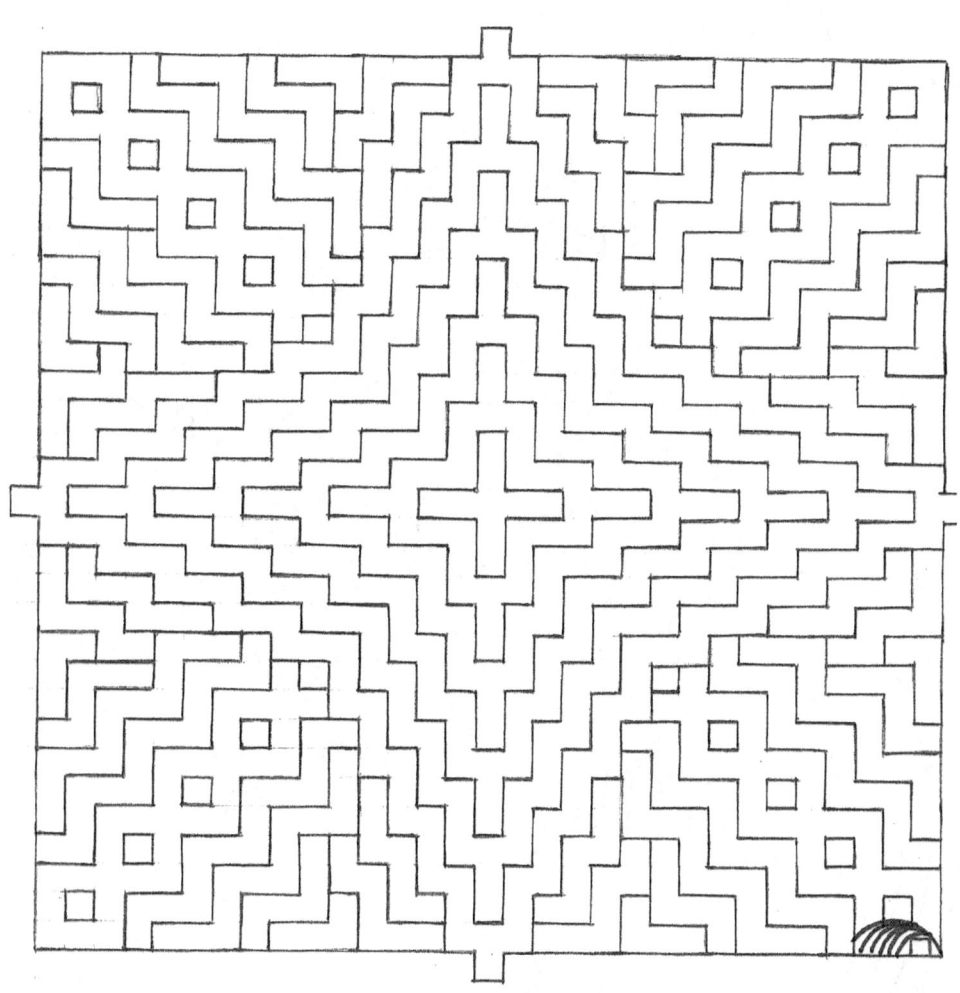

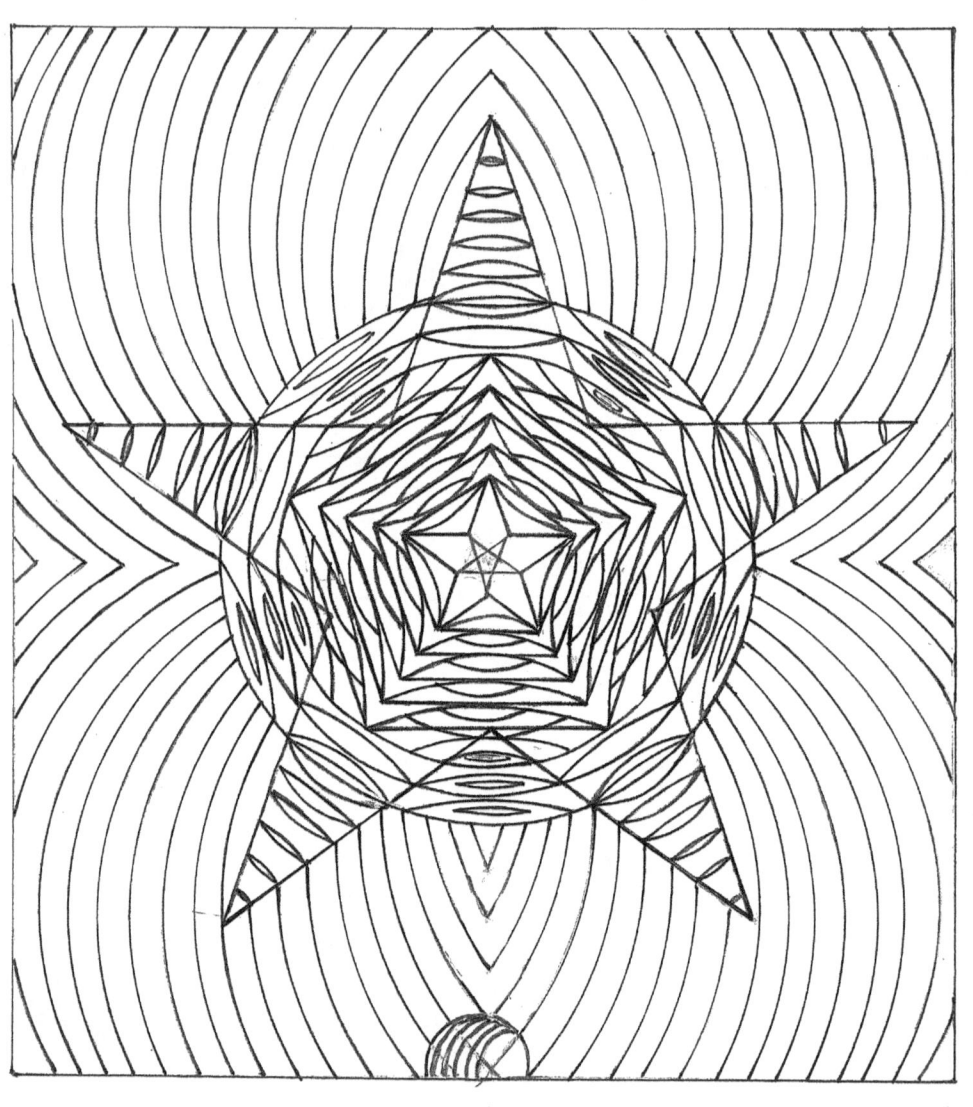

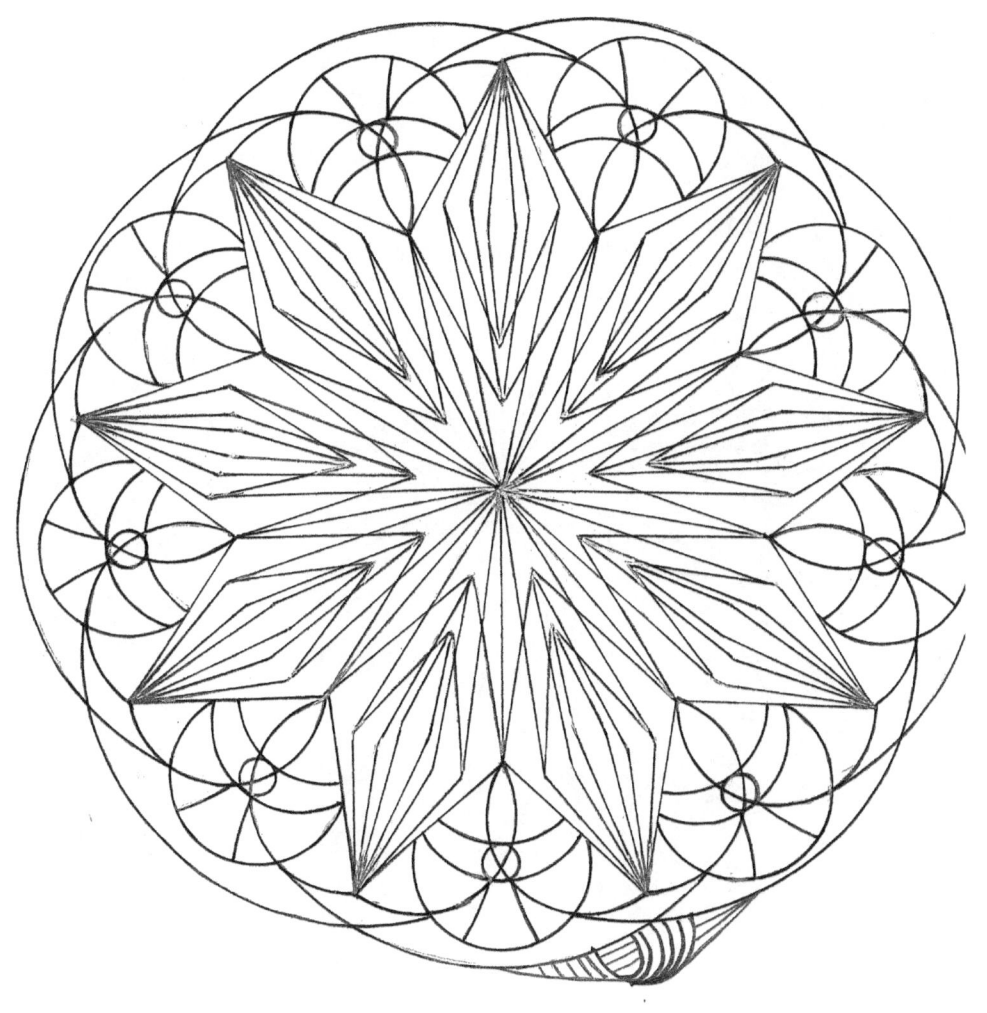

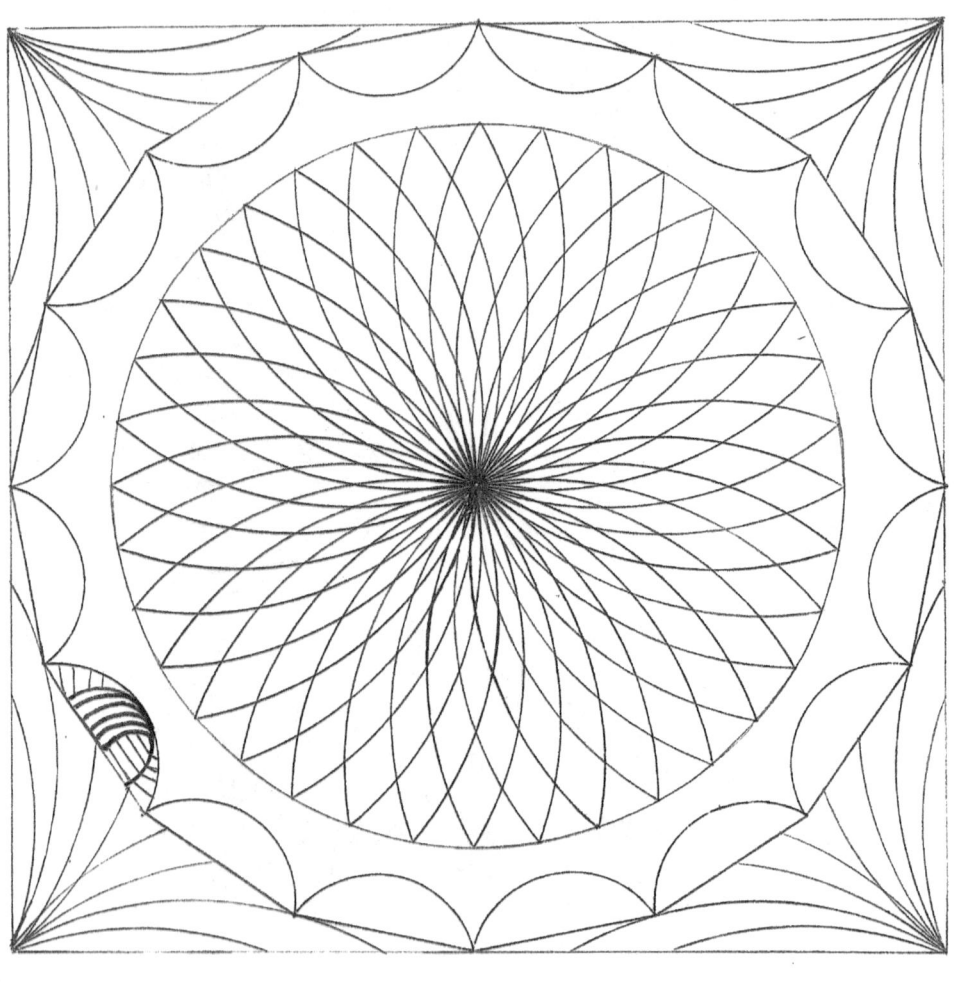

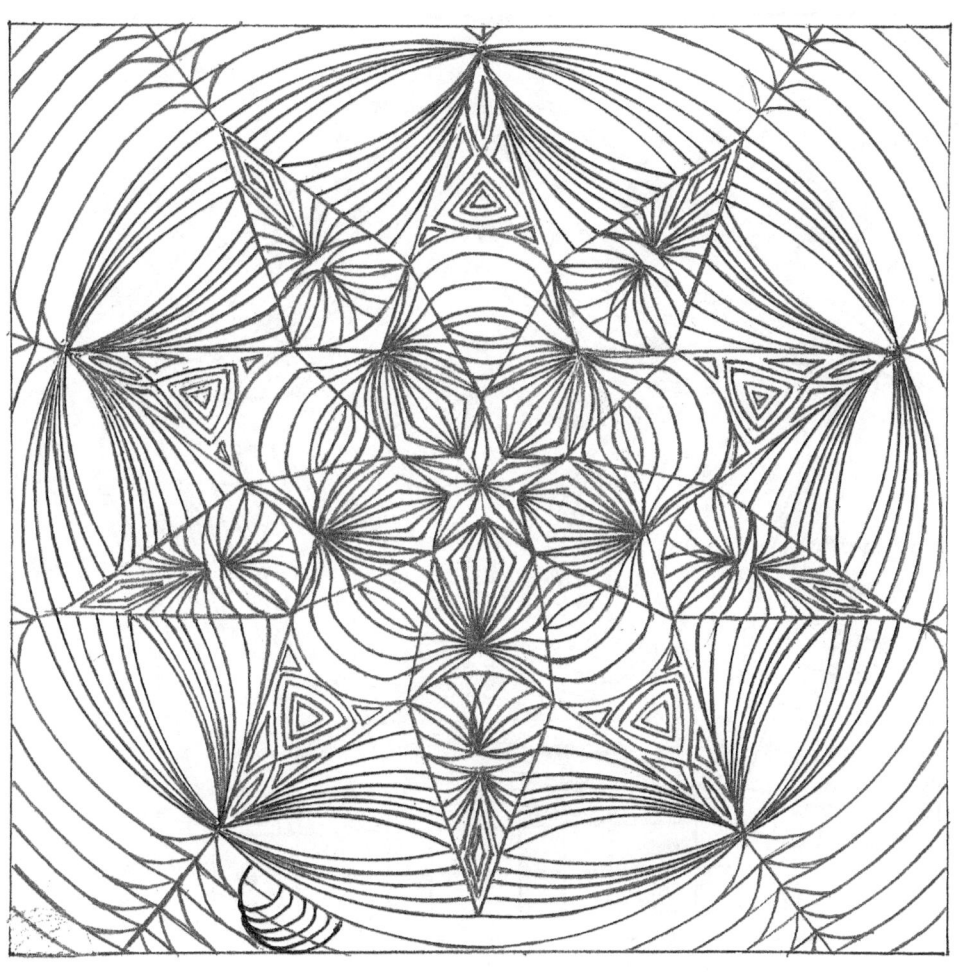

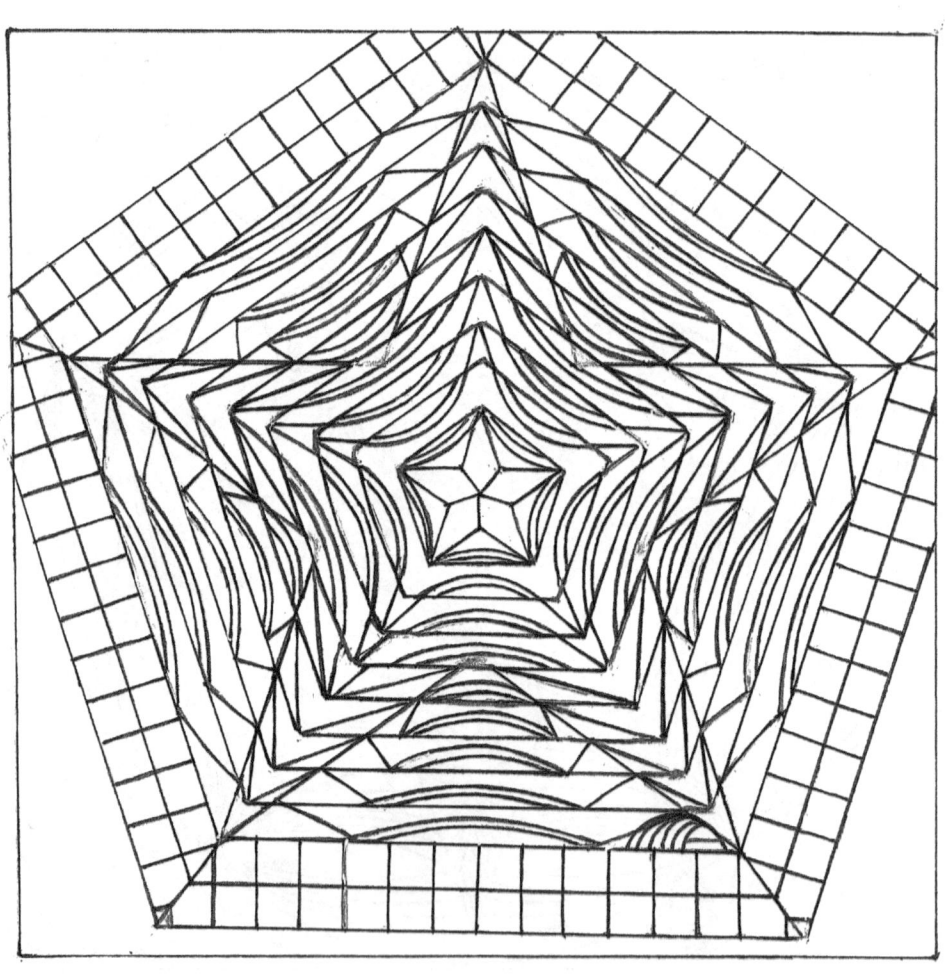

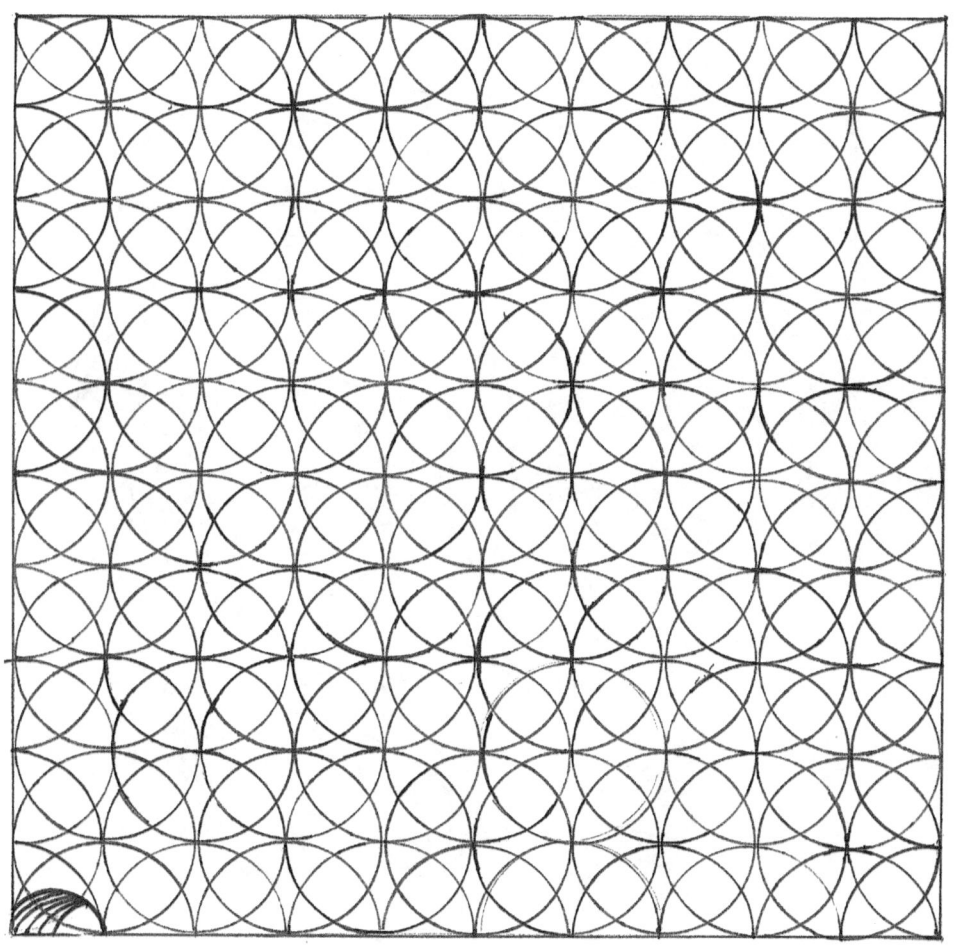

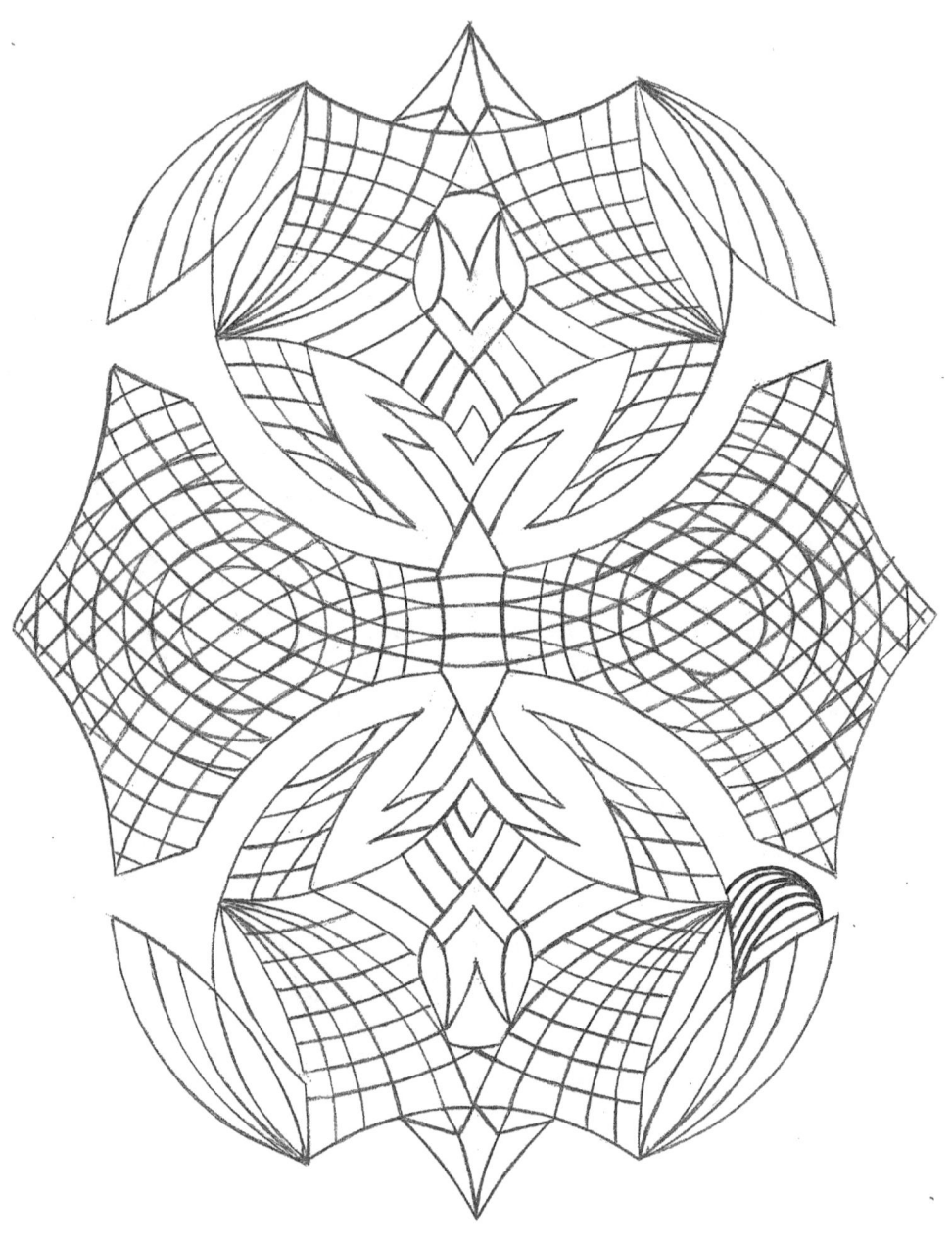

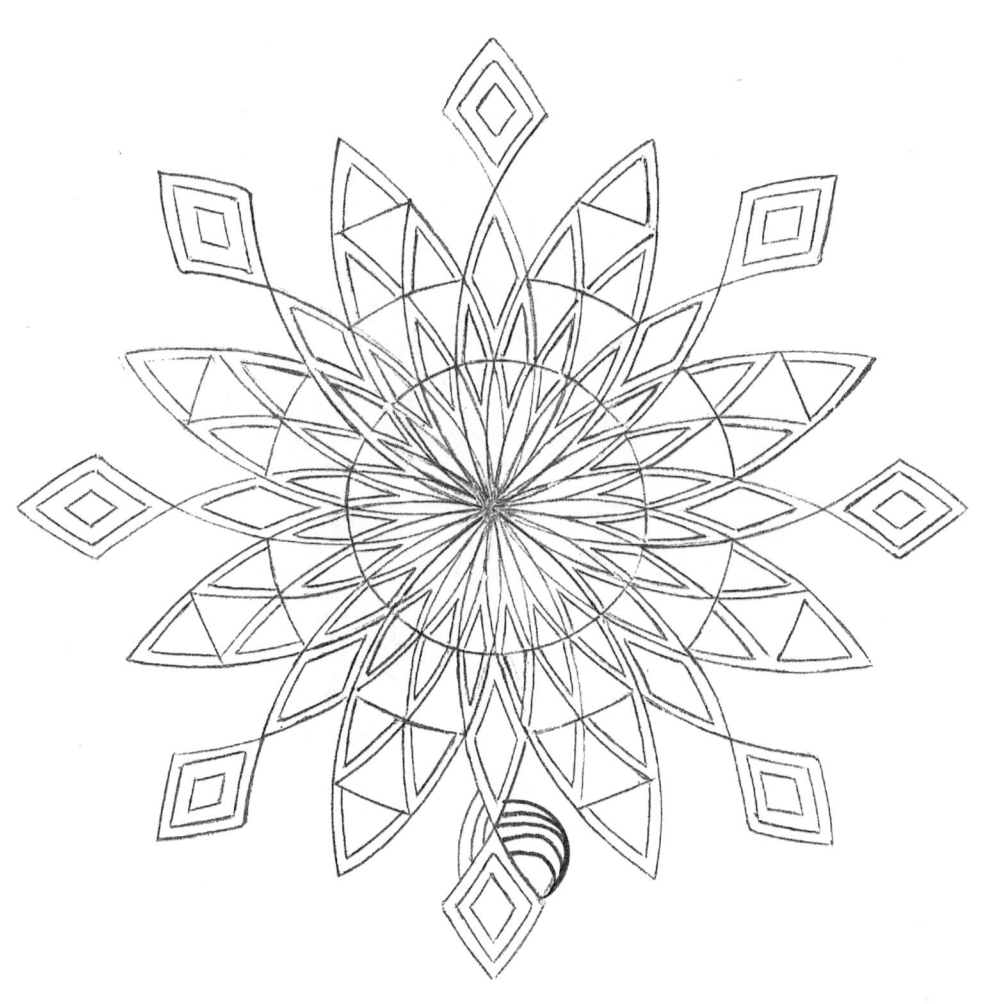

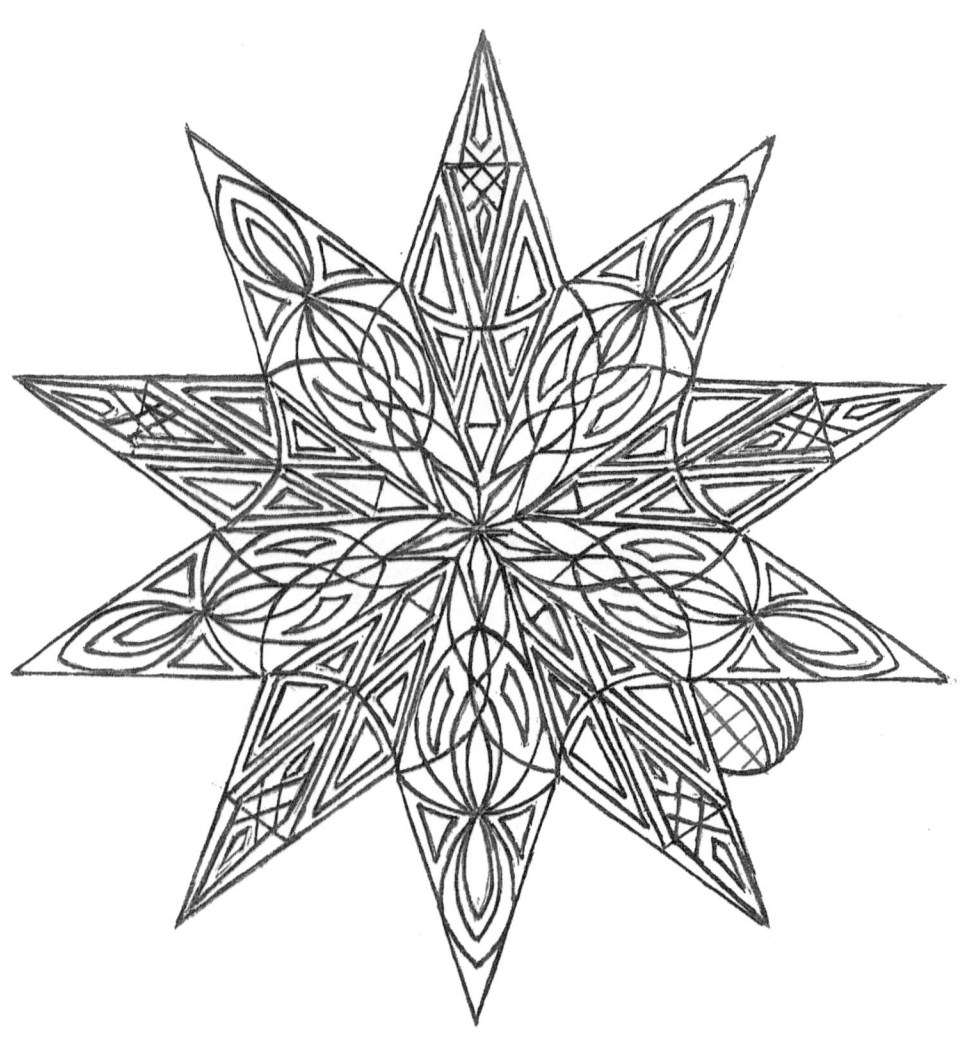

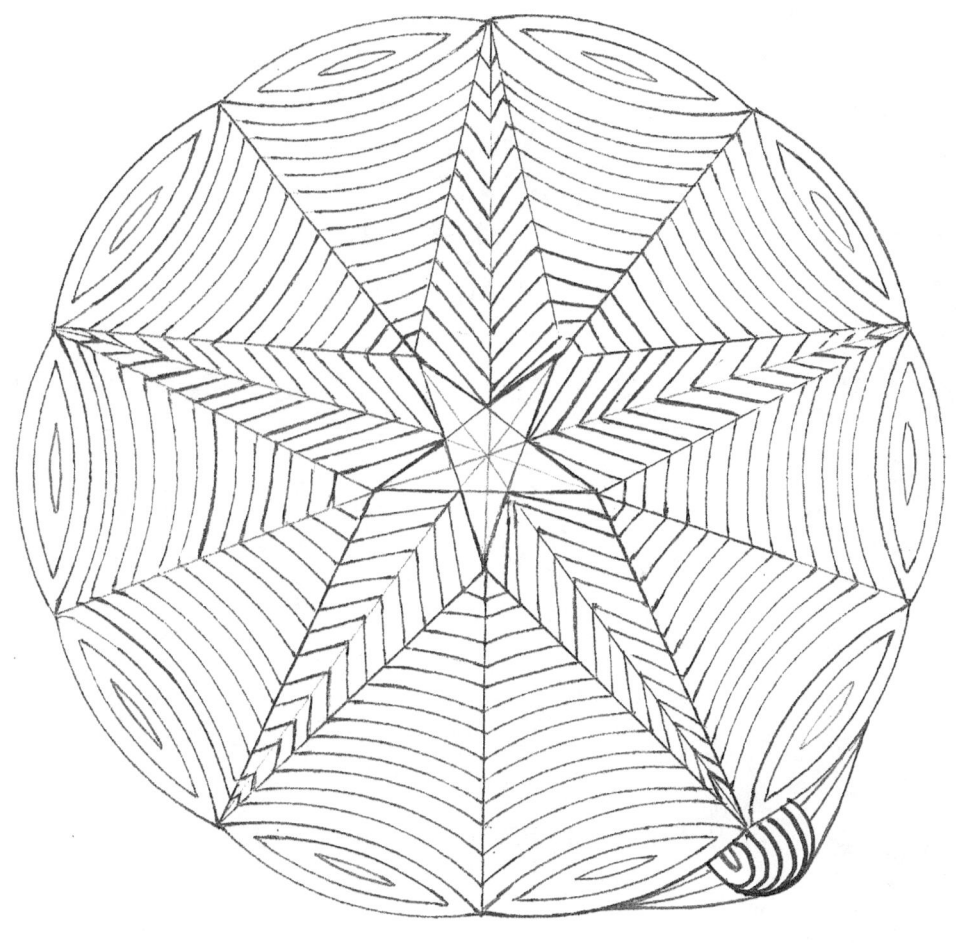

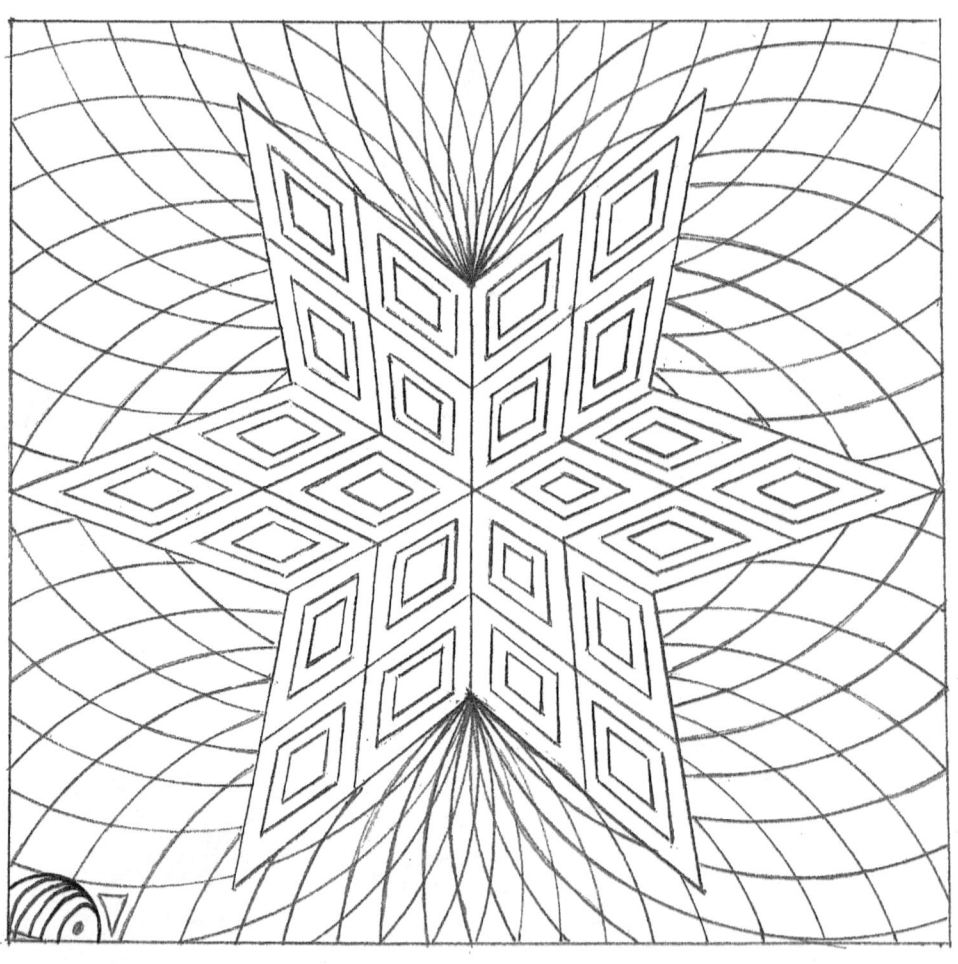

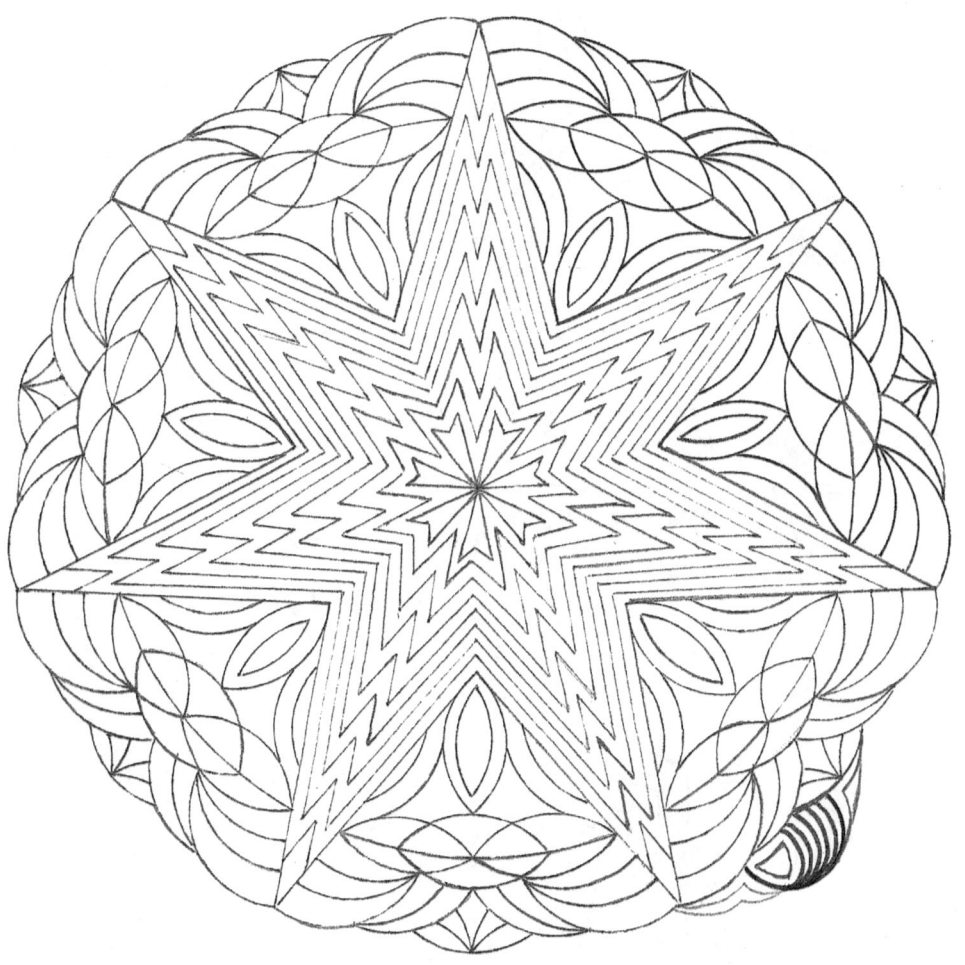

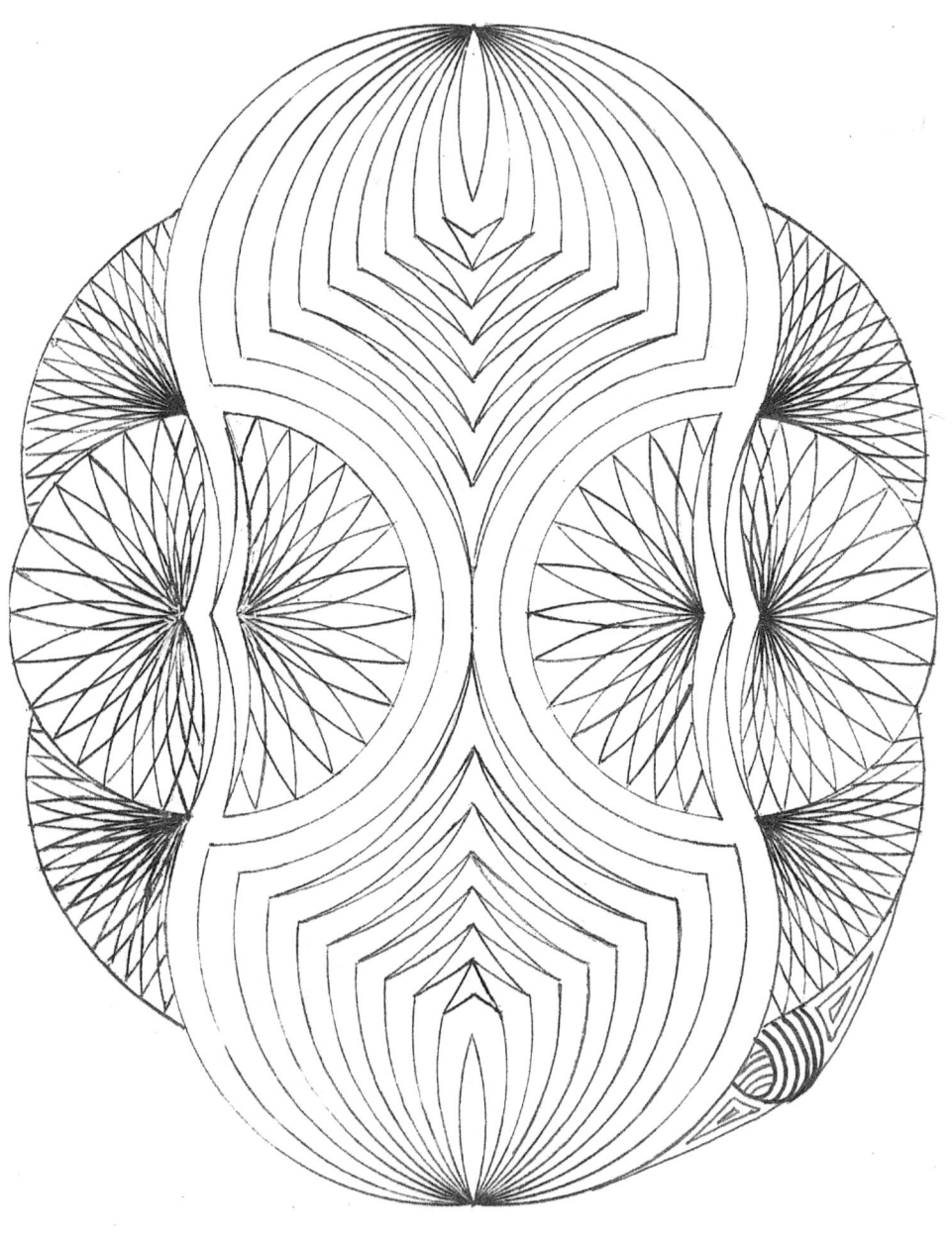

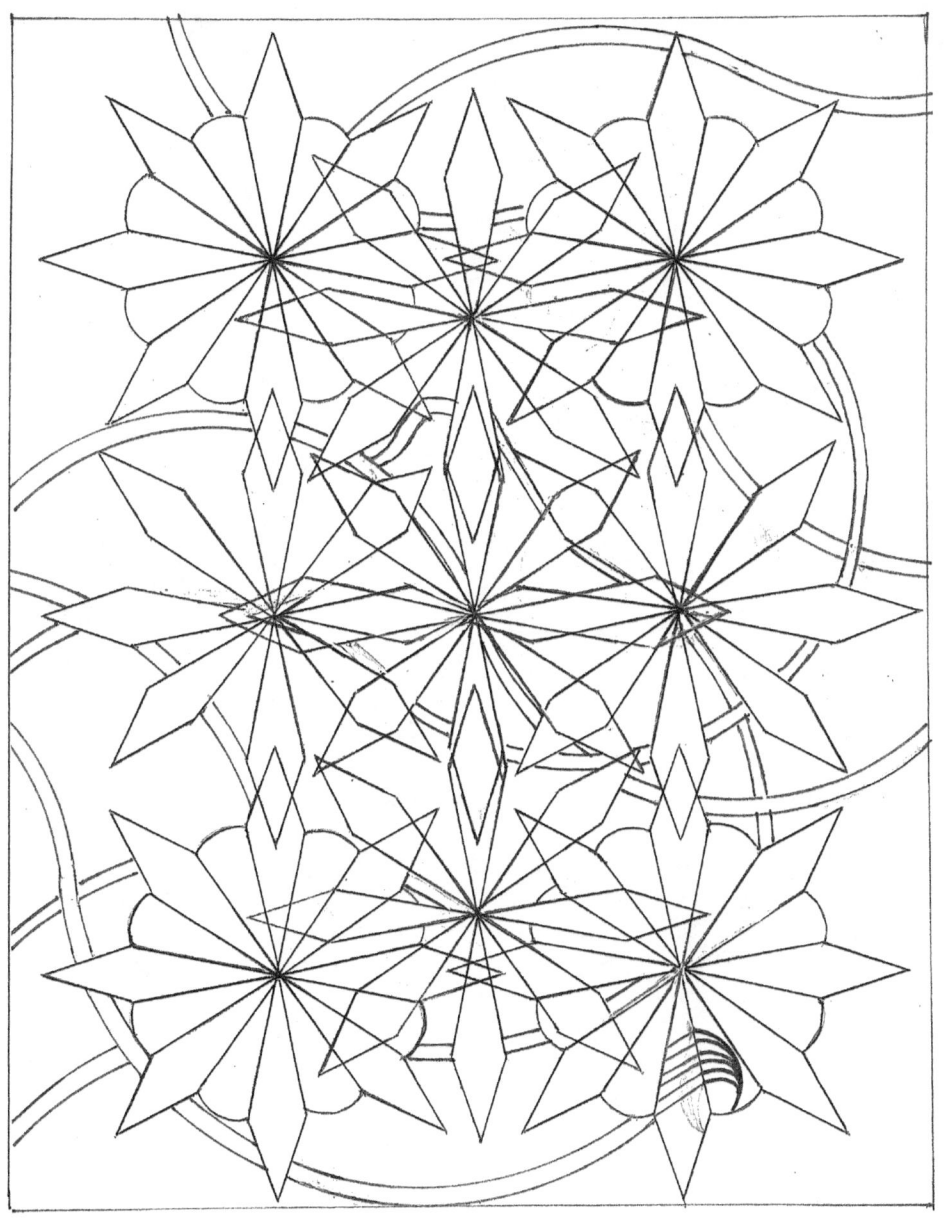

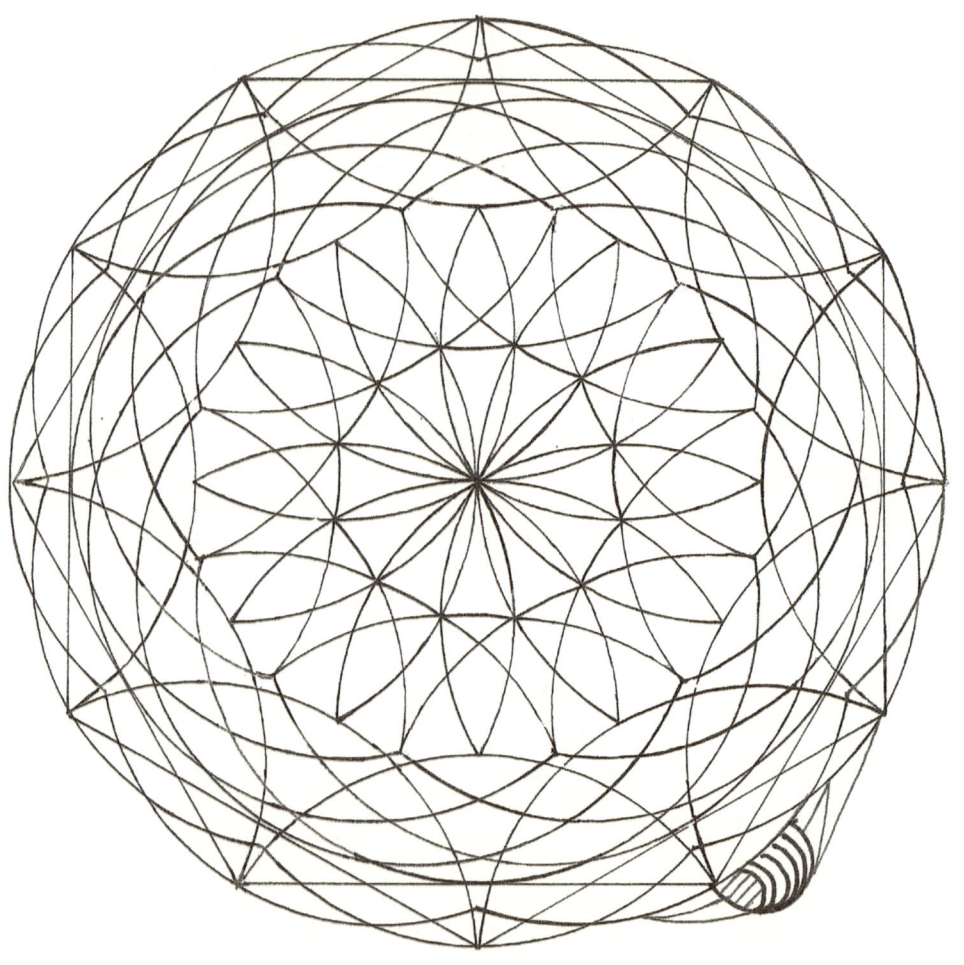

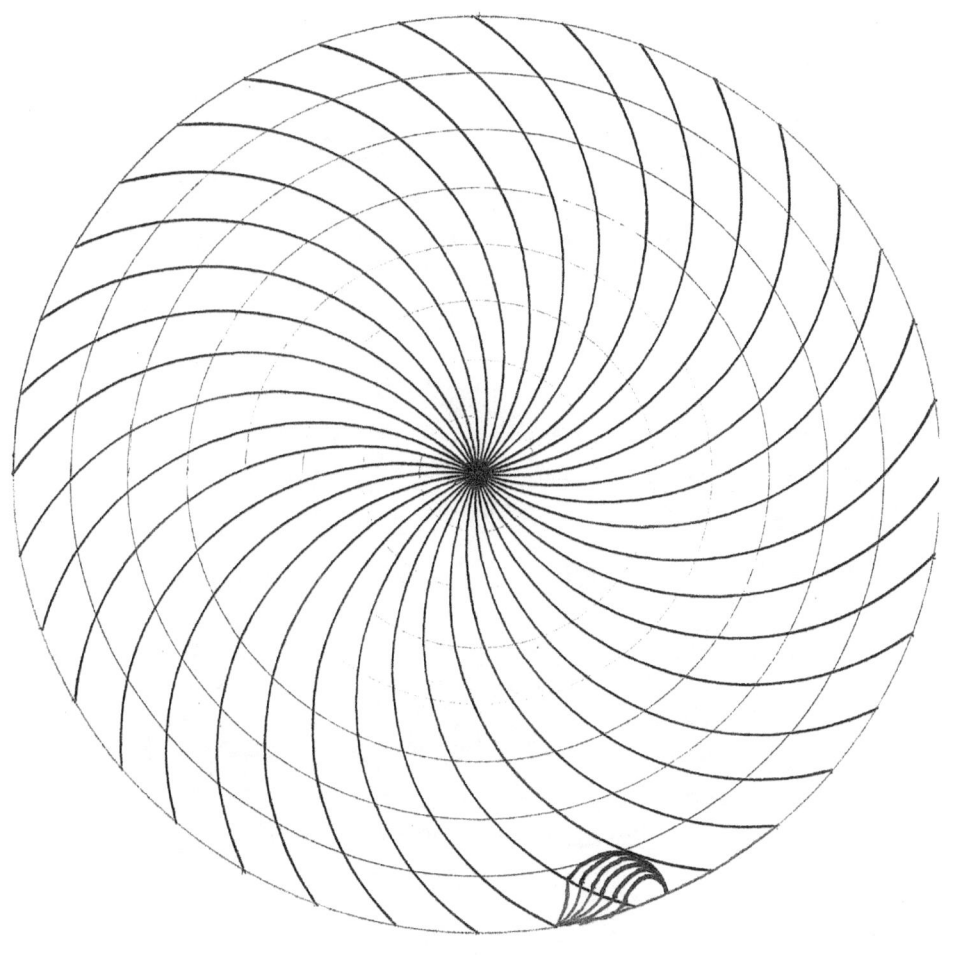

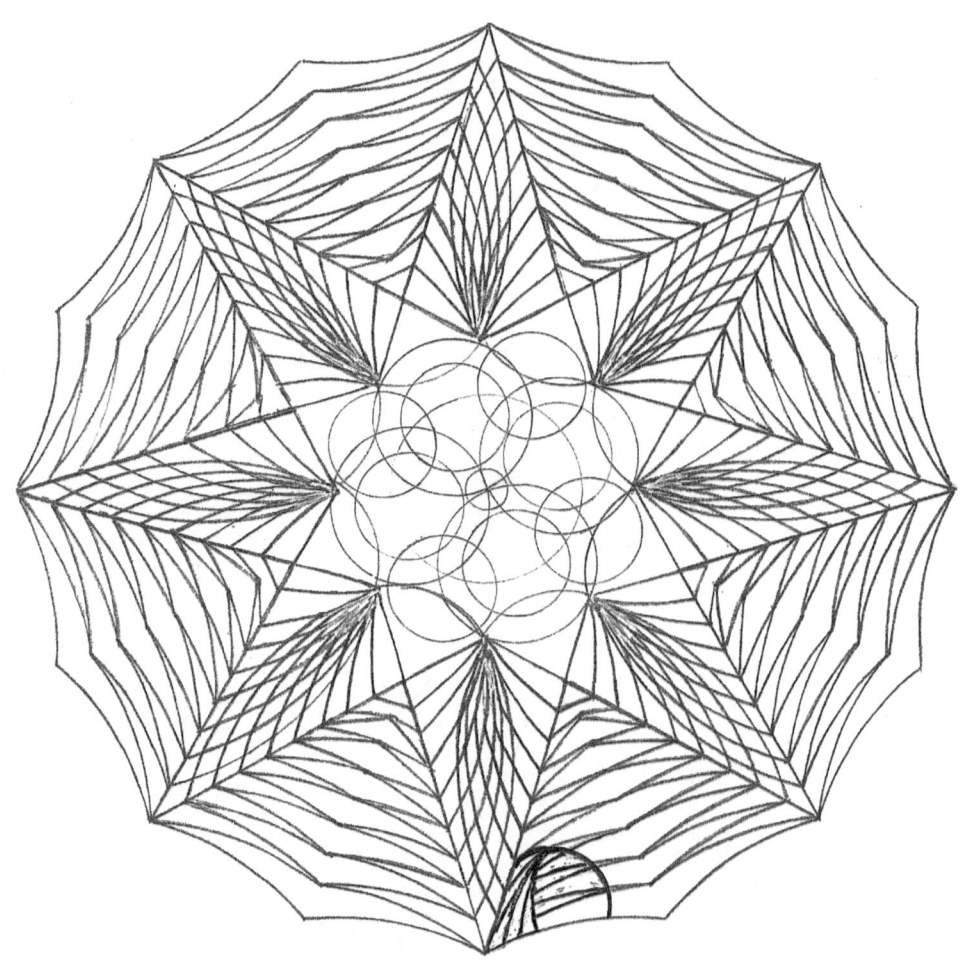

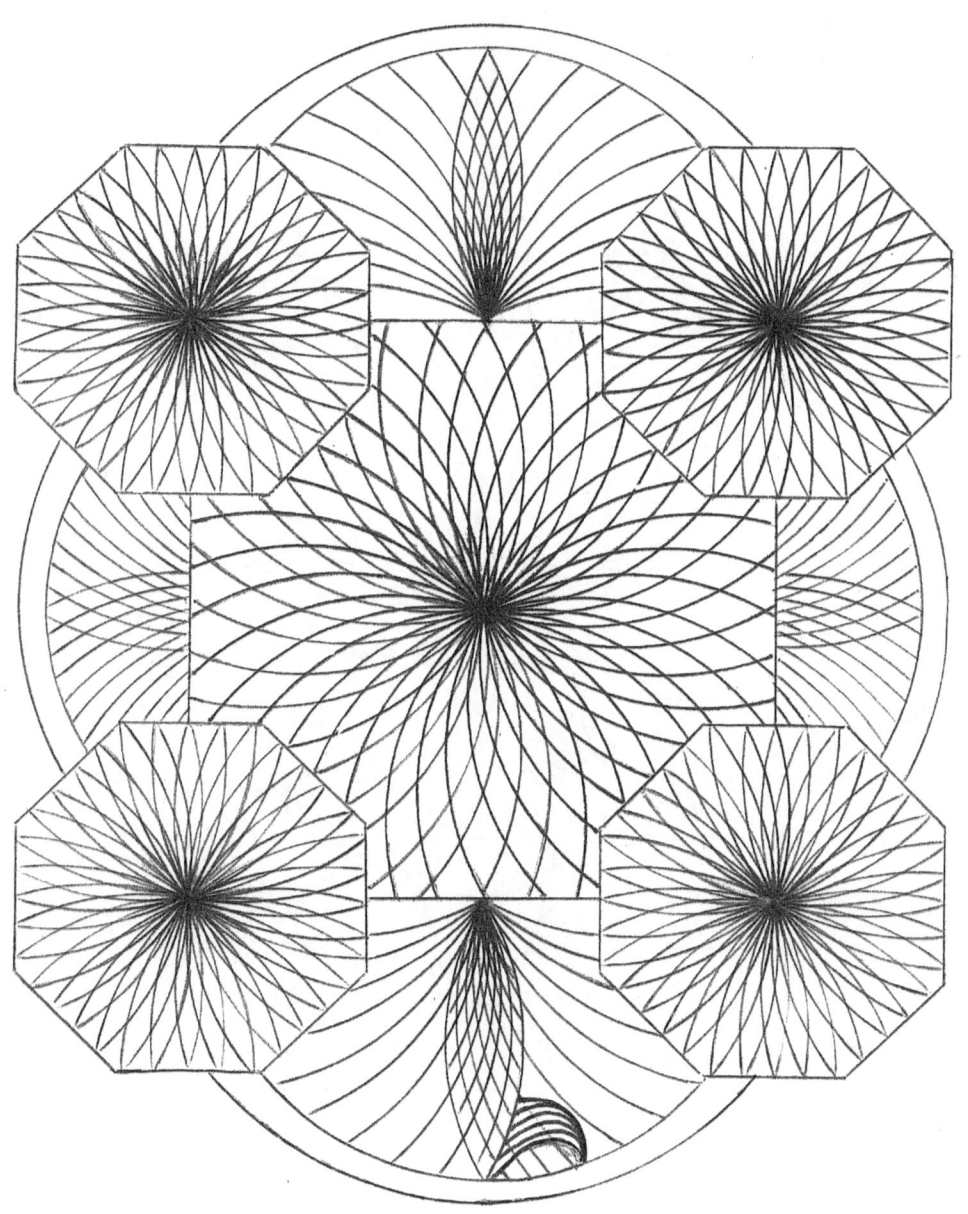

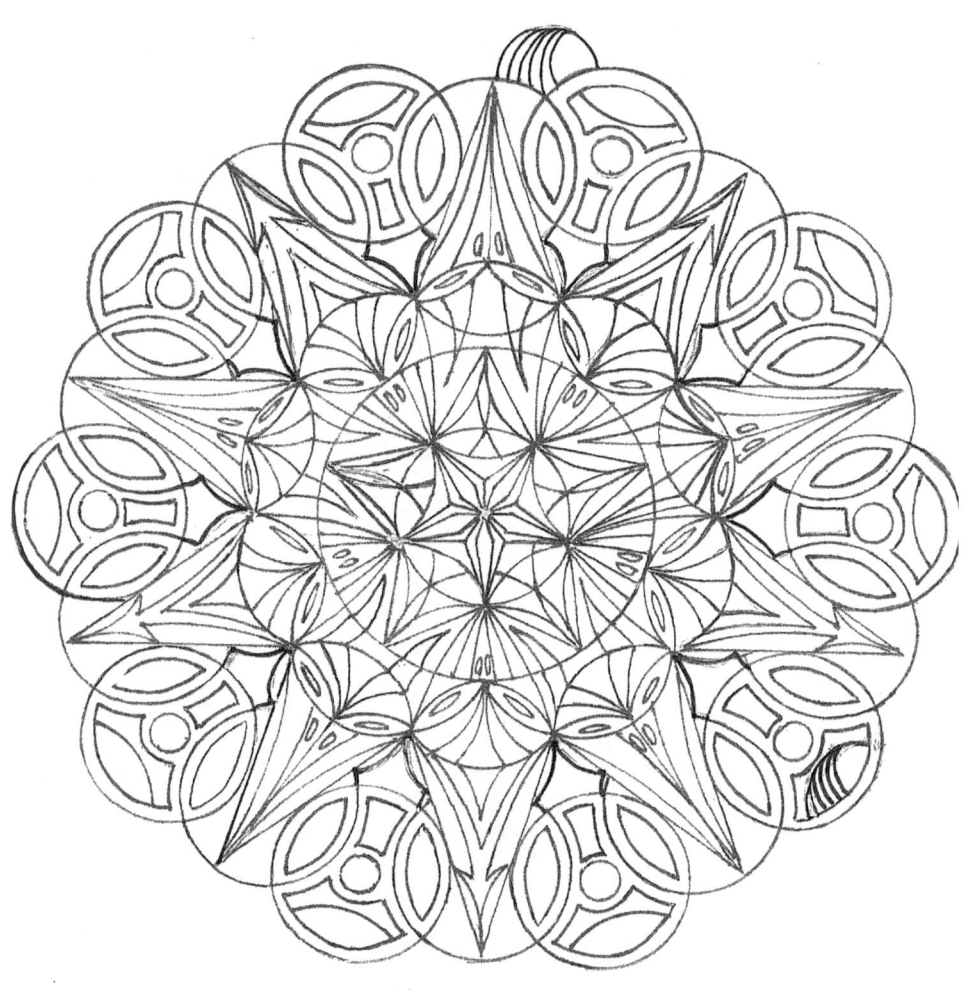

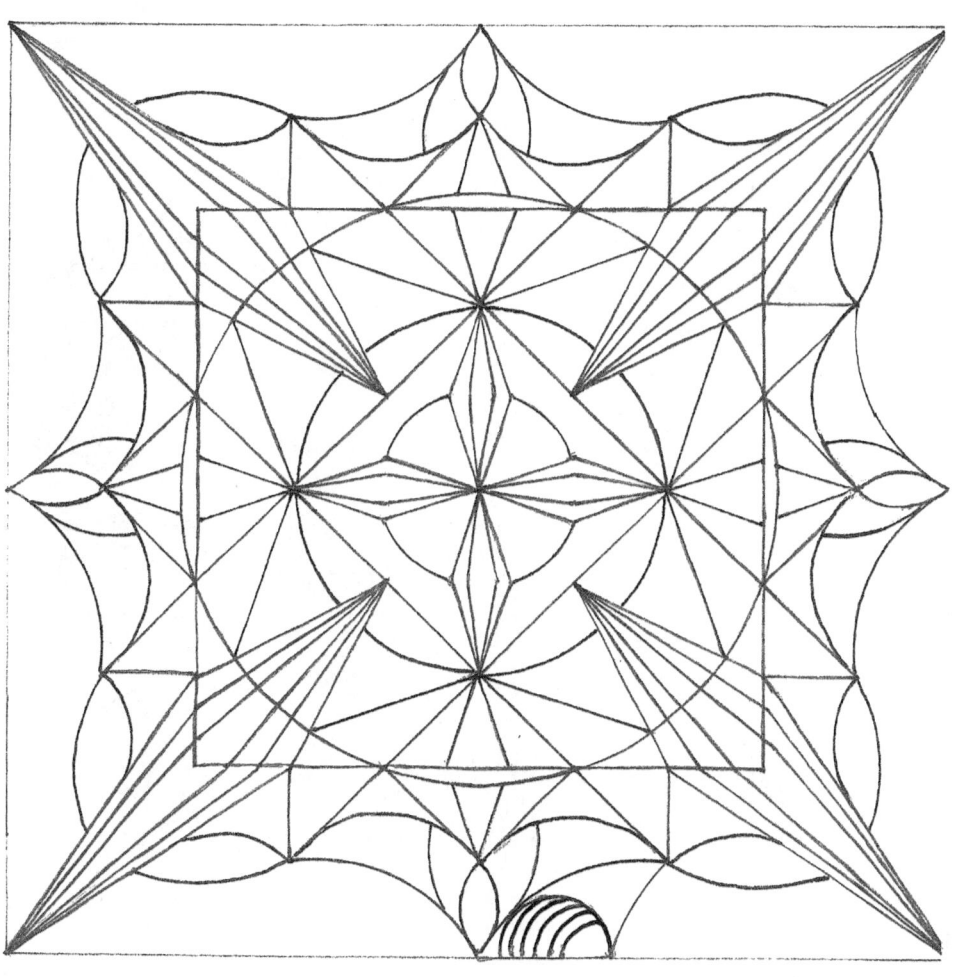

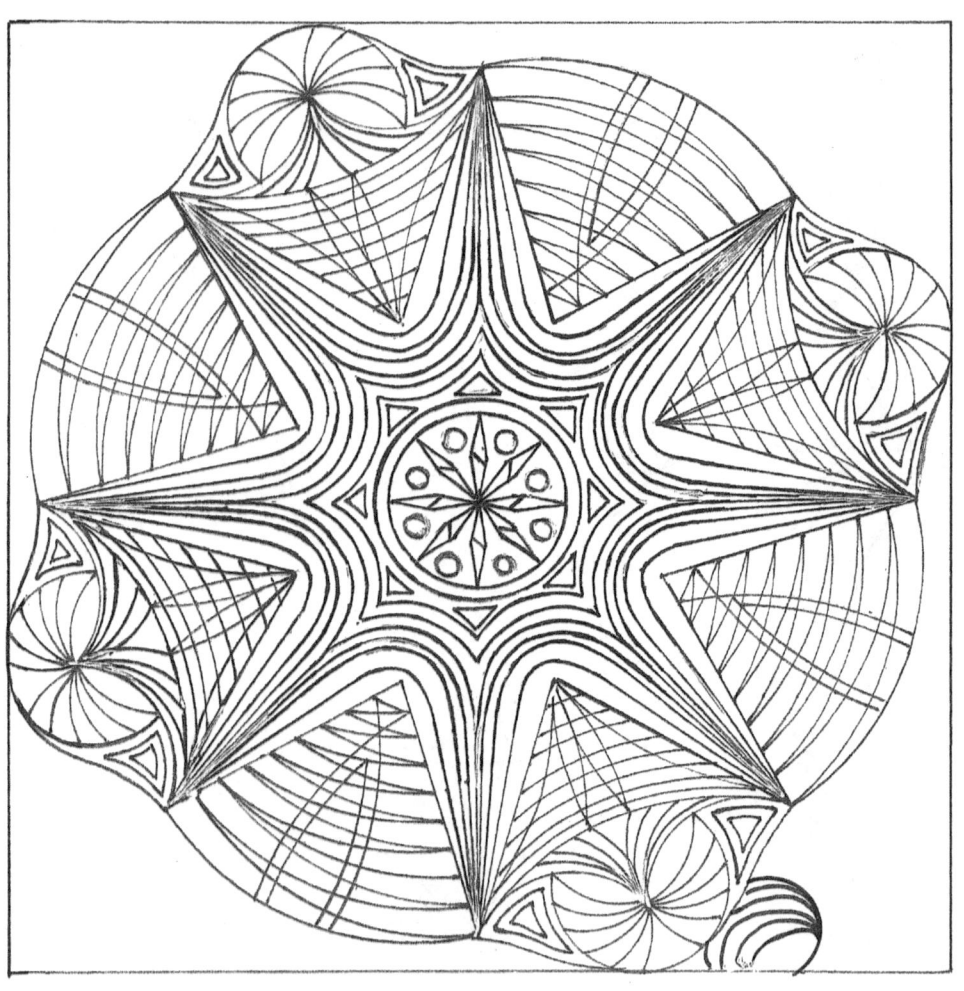

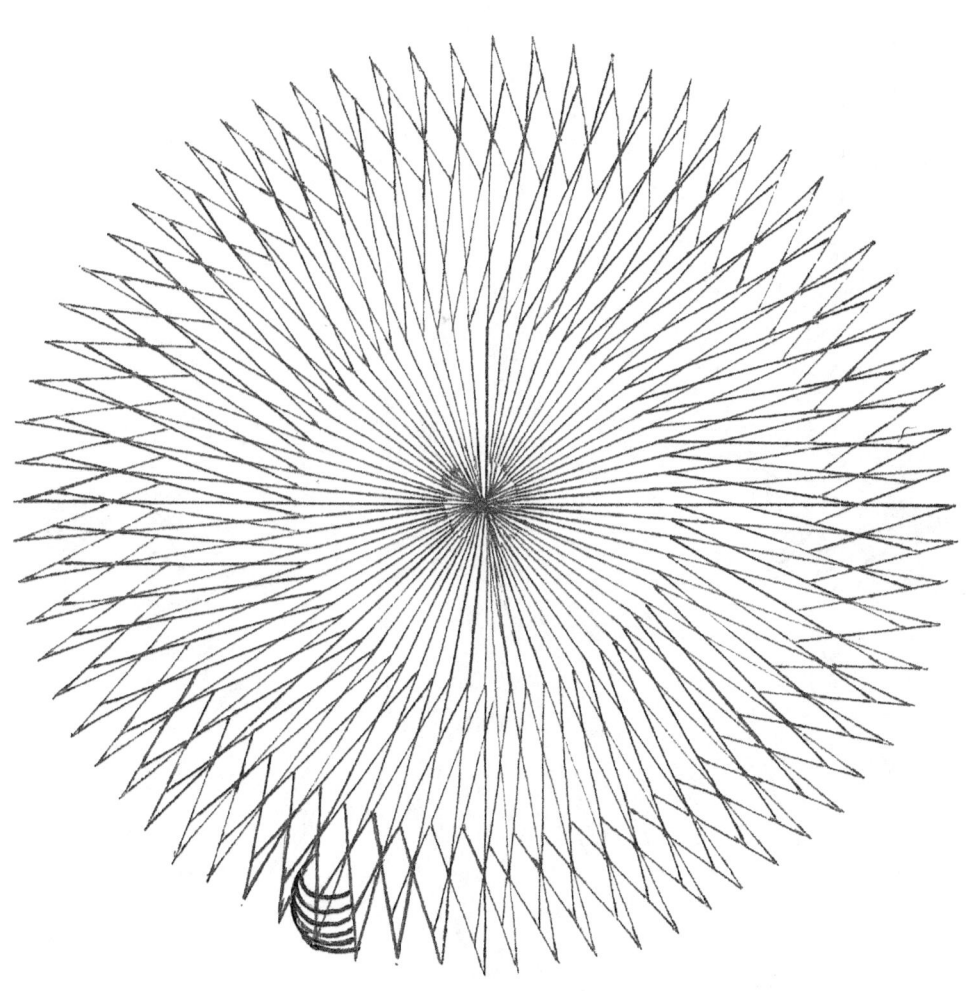

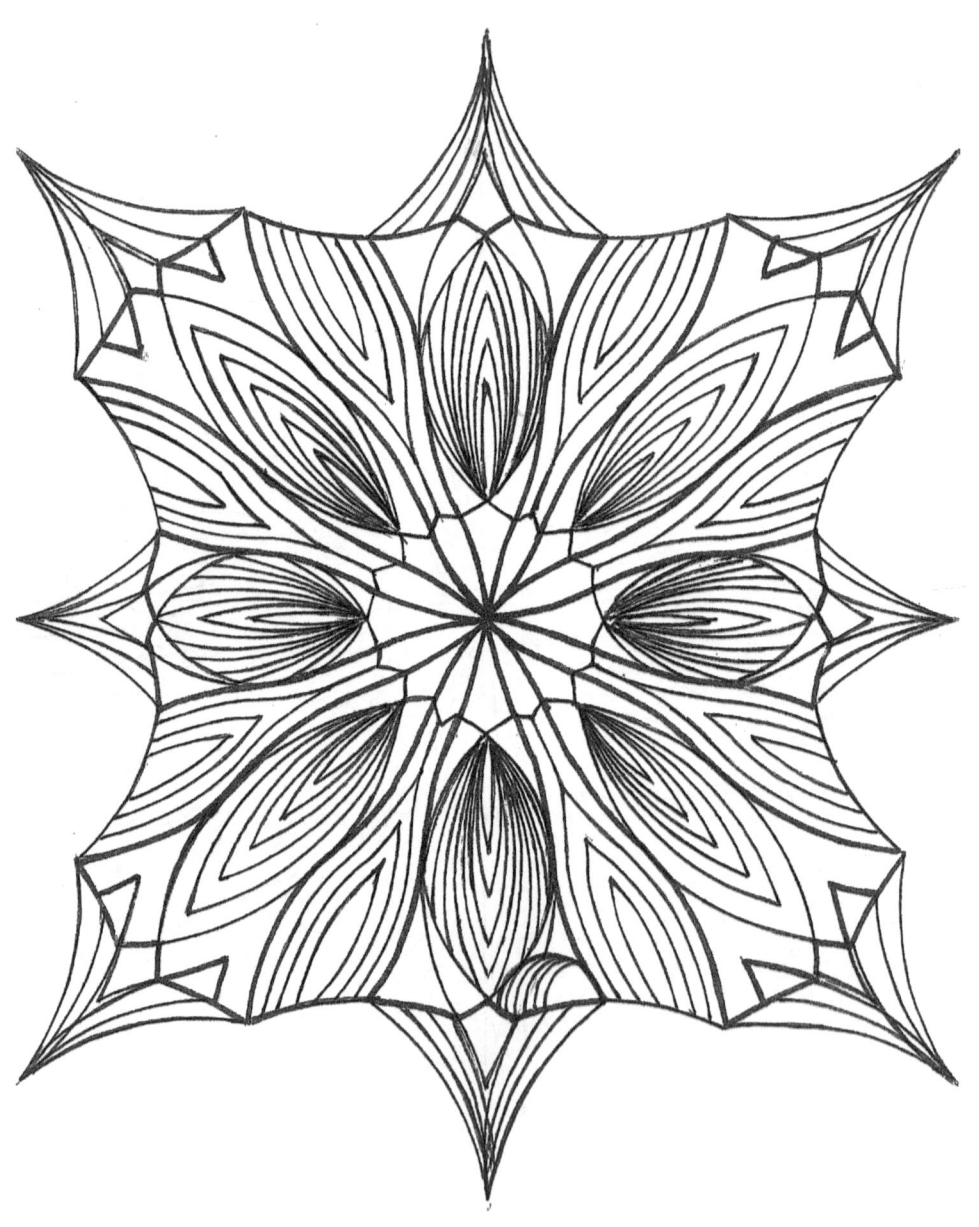

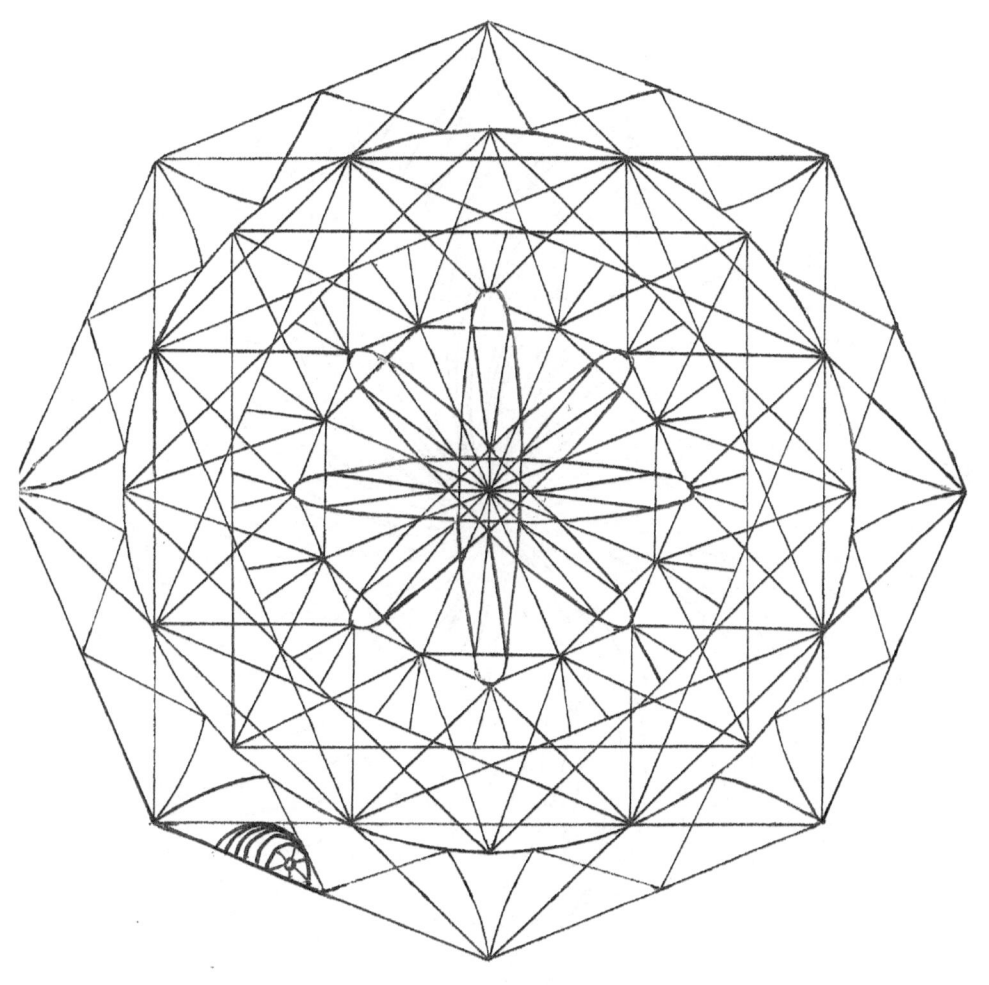

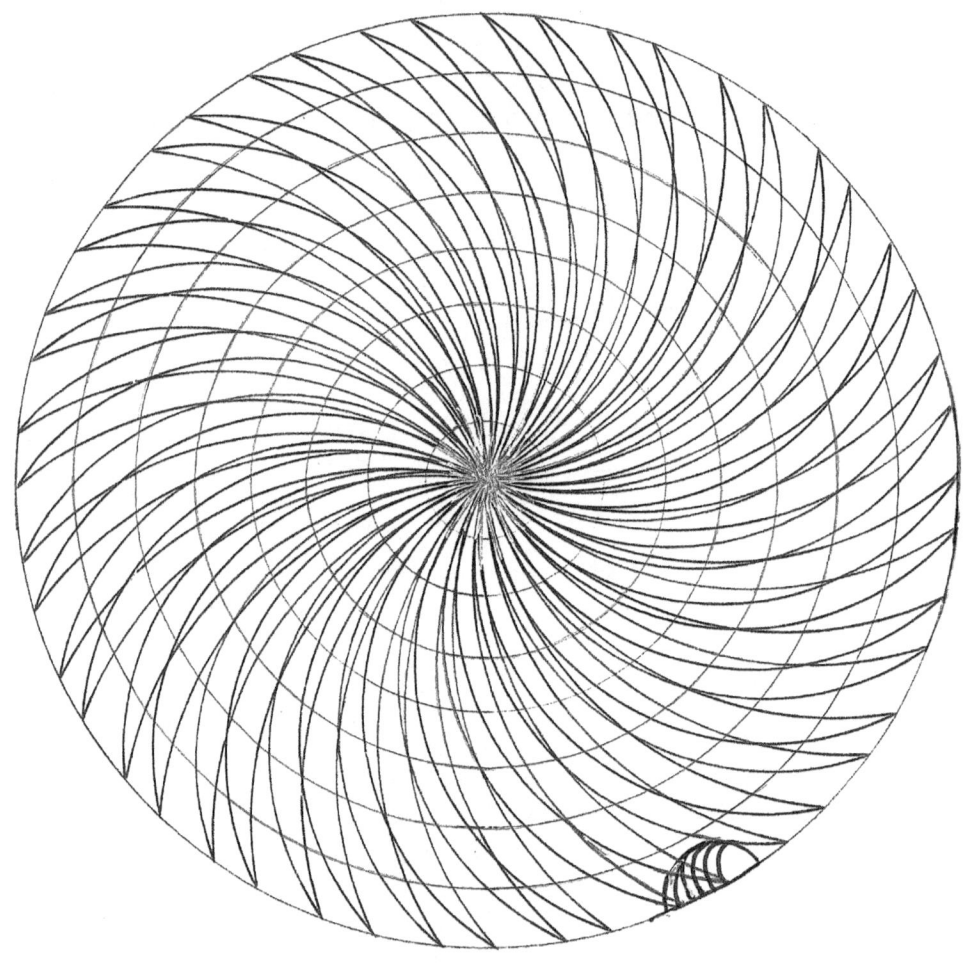

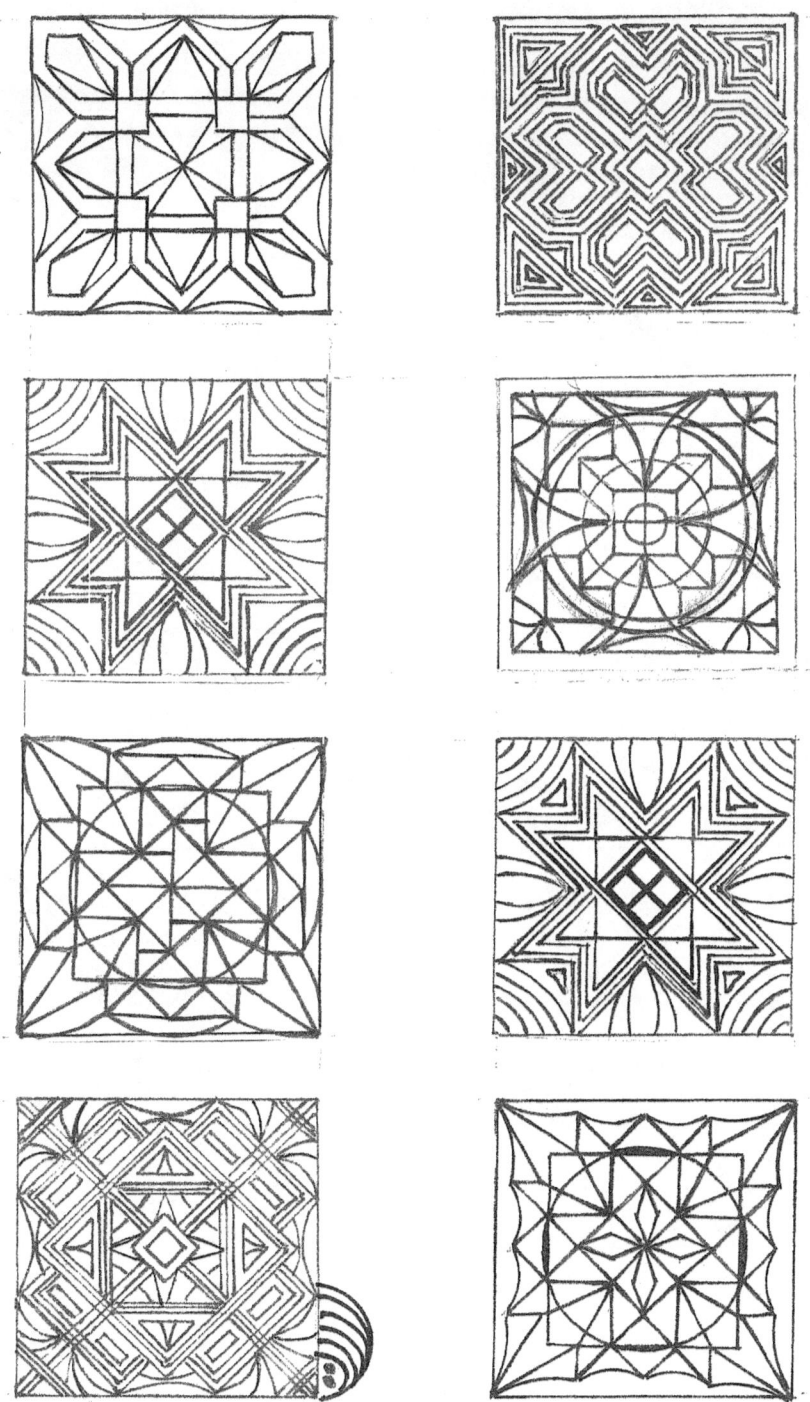

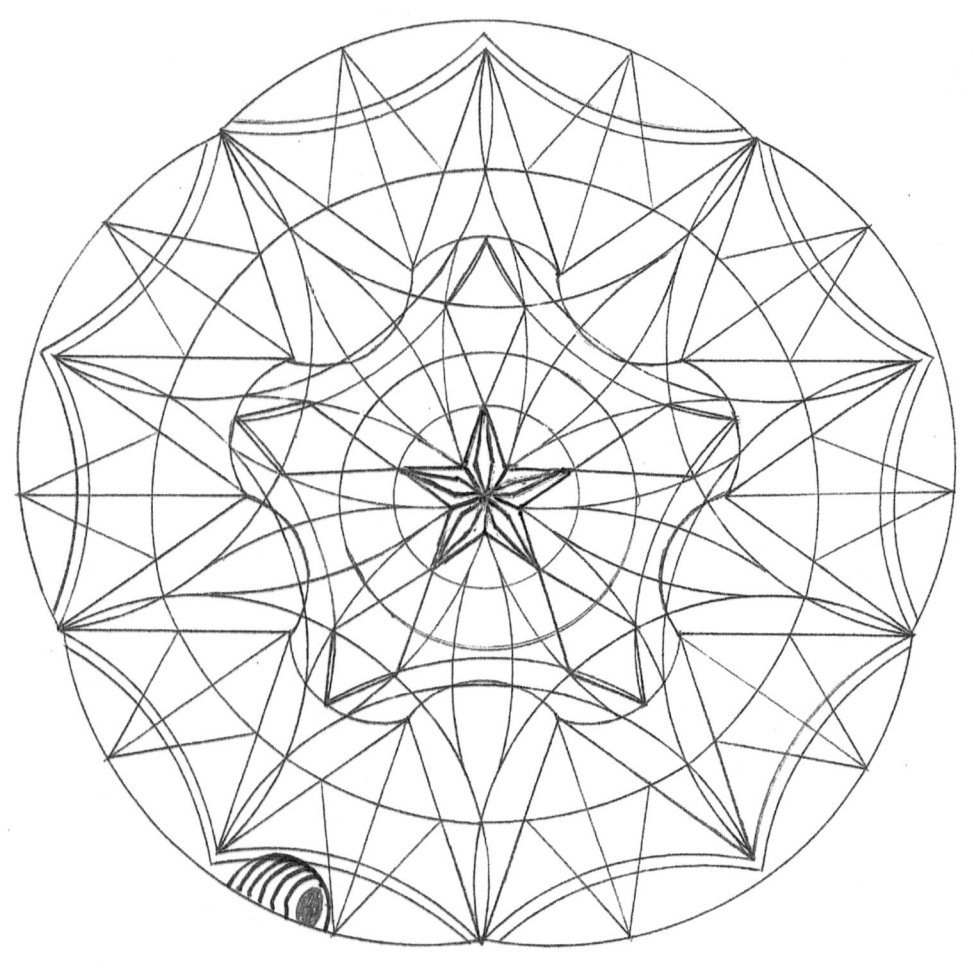

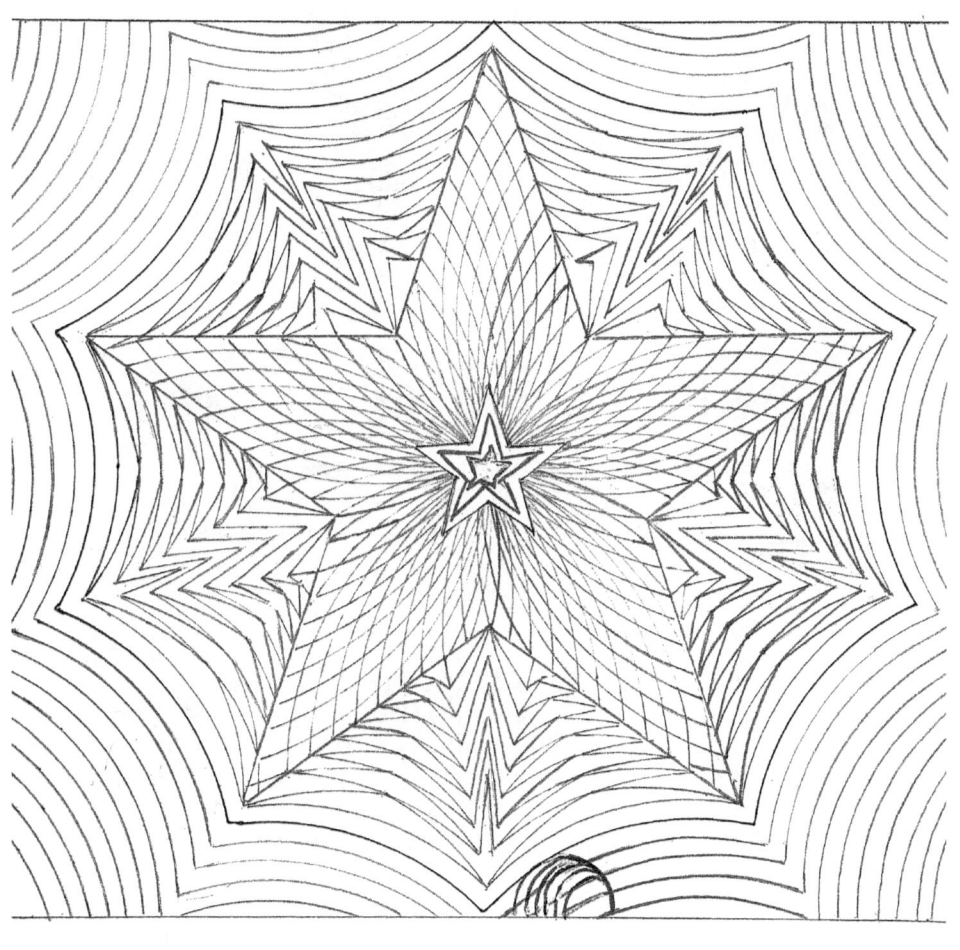

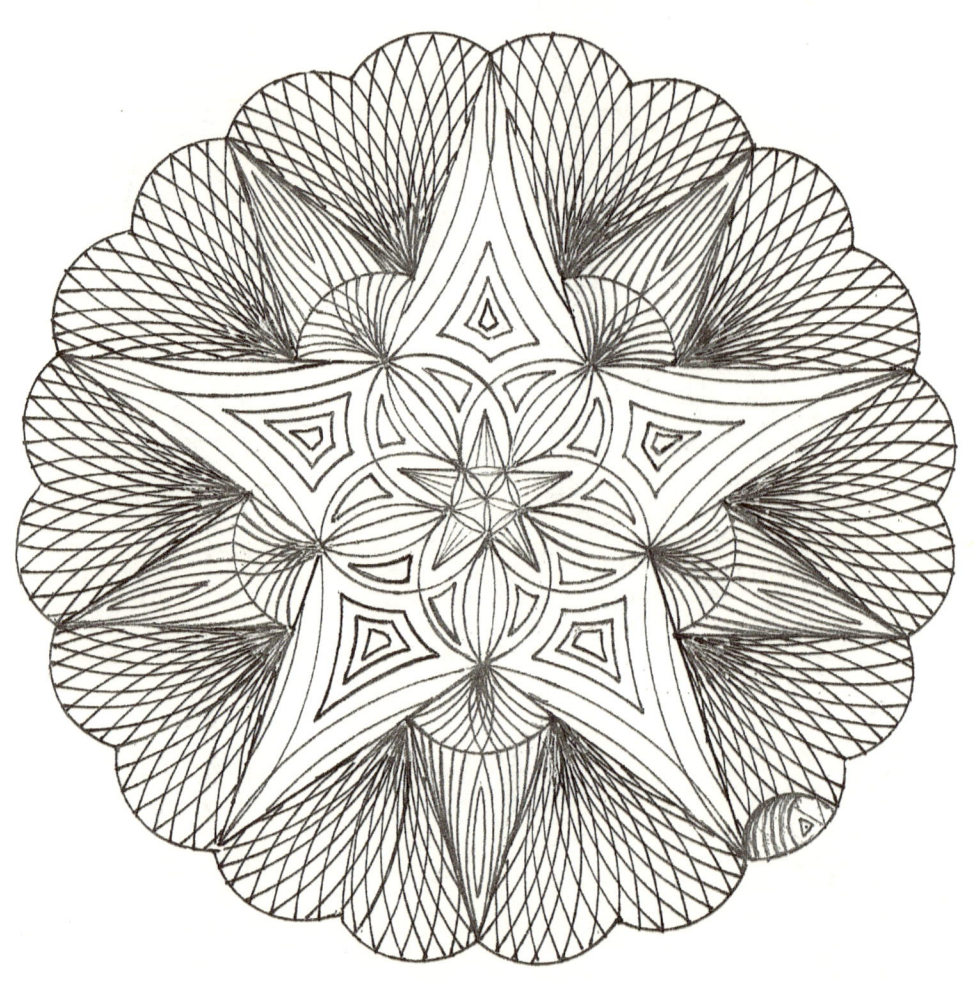

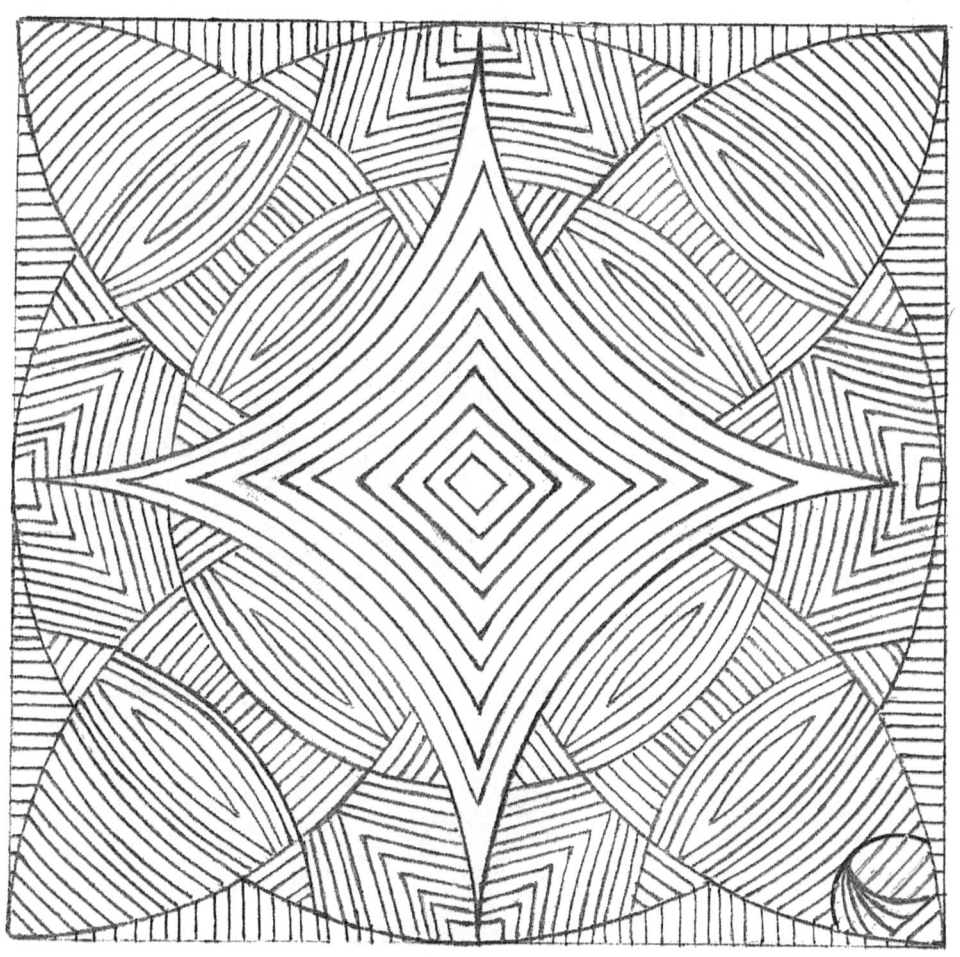

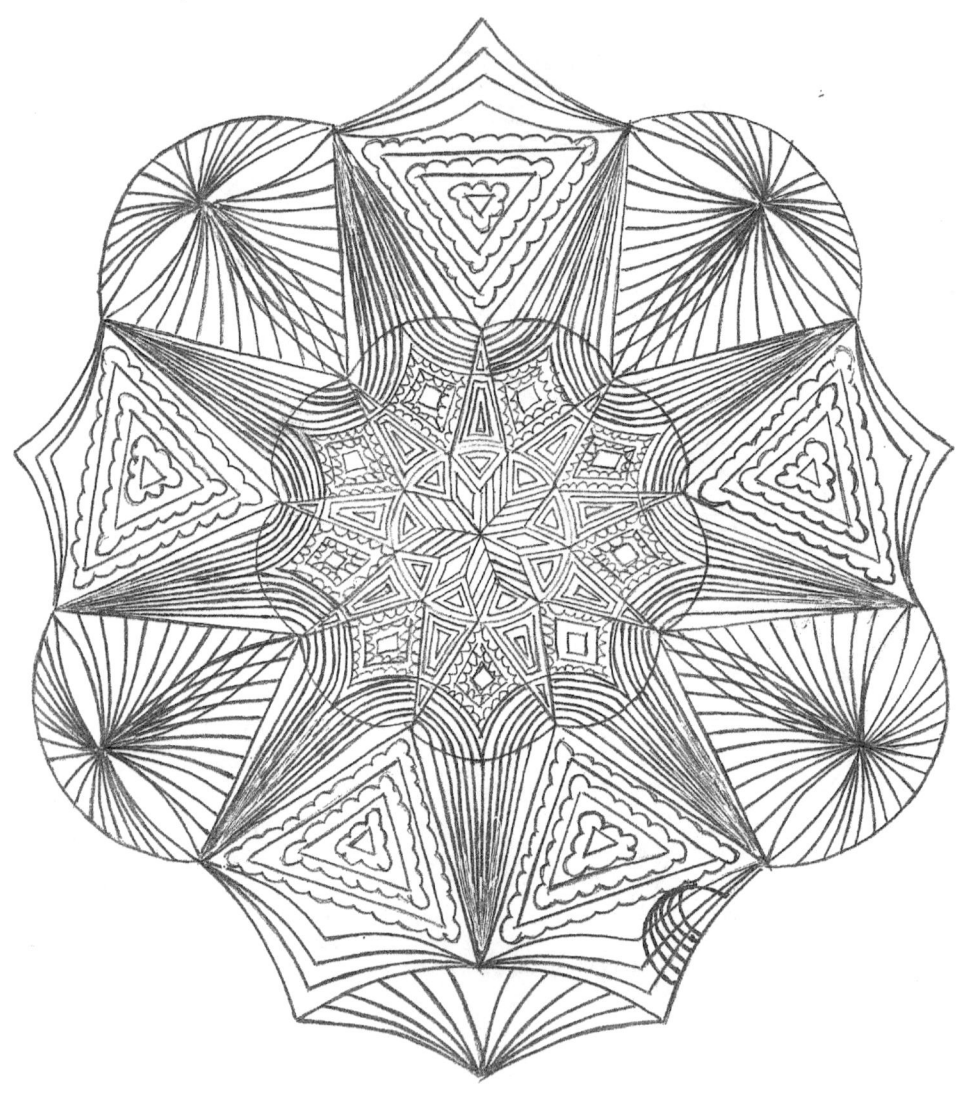

www.ingramcontent.com/pod-product-compliance
Lightning Source LLC
Chambersburg PA
CBHW021023180526
45163CB00005B/2080